NORWICH
THROUGH TIME
Frank Meeres

AMBERLEY PUBLISHING

First published 2010

Amberley Publishing Plc
Cirencester Road, Chalford,
Stroud, Gloucestershire, GL6 8PE

www.amberley-books.com

Copyright © Frank Meeres, 2010

The right of Frank Meeres to be identified as the
Author of this work has been asserted in accordance
with the Copyrights, Designs and Patents Act 1988.

ISBN 978 1 84868 458 4

British Library Cataloguing in Publication Data.
A catalogue record for this book is available from
the British Library.

Typeset in 9.5pt on 12pt Celeste.
Typesetting by Amberley Publishing.
Printed in the UK.

Contents

Acknowledgements and References

Many of the historic photographs are from sources at the Norfolk Record Office; I am grateful to Dr John Alban, County Archivist, for permission to use these images. The references are:

ACC 2003/210: pages 51-55, 88
ACC 2009/177: pages 7, 14, 15, 32, 33, 39, 60
BR 35/4/19: page 81
BR 241/4: pages 38, 80, 84
BR 271/169: page 87
C/WT 1/6/1/3: page 94
MC 39/9: page 82
MC 365/74-80: pages 20, 22-27
MC 389/78, 79: pages 79-83
MC 2343: pages 28, 56, 58, 71, 91
MC 2678/2,3: pages 10, 11, 30, 69, 70
N/LM 2/11,12: pages 13, 36, 59, 76, 78, 90
PS 1/19/2: pages 18, 66, 95

The images on pages 41, 50 are from the photograph collection of the United States Army Air Force held at the Record Office (reference MC 371/908). I am grateful to the American Memorial Library in Norwich for permission to use these photographs.

Norfolk Record Office colleagues also helped. Thank you to Edwin King for two historic photographs, to Victoria Horth for two modern images, and to Tom Townsend for the modern image of the Guildhall, under scaffolding when this book was in preparation.

Introduction

One of the first written mentions of Norwich is in the year 1004 when, according to the *Anglo-Saxon Chronicle*, the Viking king Sweyn sailed with his fleet up the river Wensum and burned Norwich to the ground. This introduces three themes that relate to the whole history of the city: the influence of Europe, the importance of the river and the vulnerability of the city to fire, flood, and enemy attack. The Vikings have left their mark on the city mainly in the form of street names: the 'gate' element in familiar streets like Colegate and Gildengate does not refer to any gate but is the Scandinavian word *gata*, meaning way or road.

The next group of settlers, however, completely altered the shape of the city and created the landscape that we see today. The Normans took over Norwich after 1066 and erected the two most iconic buildings in the city: the castle and the cathedral. Saxon houses and churches were pulled down to make way for them and the Saxon market, which had been in Tombland, was moved to the site in front of Saint Peter Mancroft where it still functions today, over nine centuries later.

For many centuries, Norwich was the largest town in England outside London. It had more churches than any other town and the longest medieval city wall. Its wealth was built on trade both throughout Norfolk and from Europe along the river, and Dragon Hall is a reminder of this activity.

Later, Norwich grew less fast and was overtaken by many of the industrial cities of the north. As well as its Anglican churches, it has a strong Nonconformist element, and the Society of Friends (Quakers) have also had a large community in the town. It has also had a proud reputation for welcoming in 'strangers', as they are known, and people from other countries; several thousand French- and Dutch- speaking immigrants came to Norwich in the 1560s and 1570s, bringing their

own characteristics into the cultural mix, such as the tulip, the Dutch gable, and the canary, which became so beloved of Norwich folk over the centuries that the football club takes its popular name, the Canaries, from them. With these elements has come a reputation for charity and also for radicalism. Norwich was the first outside London to have a specialist hospital for those with mental health problems (the Bethel Hospital), and one of the first to set up an institution caring for the blind (now the Norfolk and Norwich Association for the Blind). 'Over the Water', the area north of the river, has developed its own personality over the centuries, and was the birthplace of two of the many women of character that the city has produced: Elizabeth Fry, the prison reformer, and Harriet Martineau, the writer.

The city's main wealth throughout history has come from weaving but an increasing diversity of businesses developed in the eighteenth and nineteenth centuries, some of which became known throughout Britain and the world. These have included Norwich Union insurance (now Aviva), Colman's mustard, Caley's 'marching chocolate', Barclay's bank and Jarrold's the printers. The iron and steel making firms of Barnards' and of Boulton and Paul also established a worldwide fame, making products as diverse as barbed wire, aeroplanes, and cast-iron prefabricated churches!

Two twentieth-century events that changed the shape of Norwich are covered in this book. The great flood of 1912 made people aware of the dreadful conditions in which many Norwich people lived, crowded around yards behind the main streets of the city. This led directly to the building of new housing estates after the First World War, like those at Mile Cross, Earlham and Lakenham; Norwich built more council houses than any city of its size. The Second World War saw considerable damage from bombing raids, especially the so-called Baedeker raids of April 1942. The changes this has produced in the city include the total rebuilding of Saint Stephen's shopping street. More recent decades have seen the development of two major new shopping centres, Castle Mall on and underneath the site of the former Cattle Market, which closed in the 1960s, and Chapel Field on the site of Caley's factory. As the factories along the river have closed in recent decades, they have been replaced by apartments and an ever-expanding river walk, one of the city's hidden delights.

Today's Norwich is a city where a medieval church can stand next to a twenty-first century shopping centre, and where a beer festival can take place in a medieval friary. This juxtaposition of past and present makes it a fascinating place for visitors and residents alike.

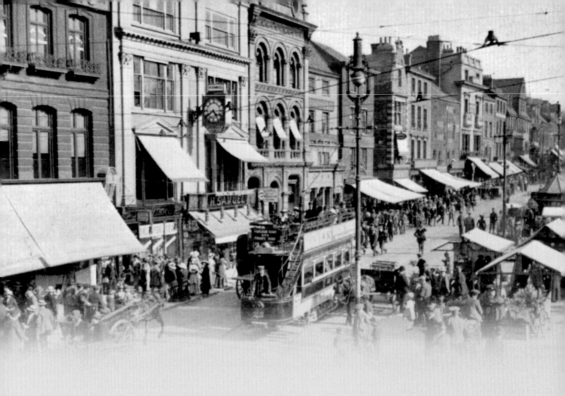

CHAPTER 1

The Two Market Places

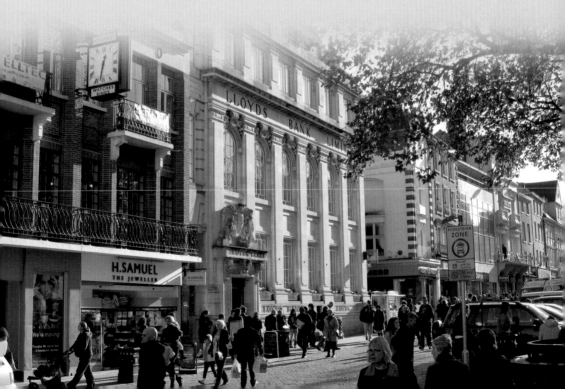

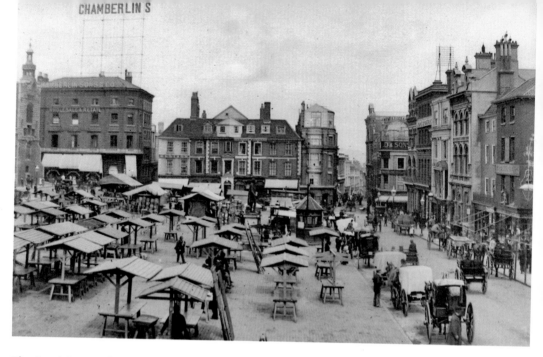

The Provision Market

The market has been in broadly the same place since the Norman Conquest, but there were significant changes in the last century, and the stalls, which in the past were cleared away each weekend, first became permanent in 1938. The market has also expanded up the hill as Victorian buildings were swept away and the new City Hall was built.

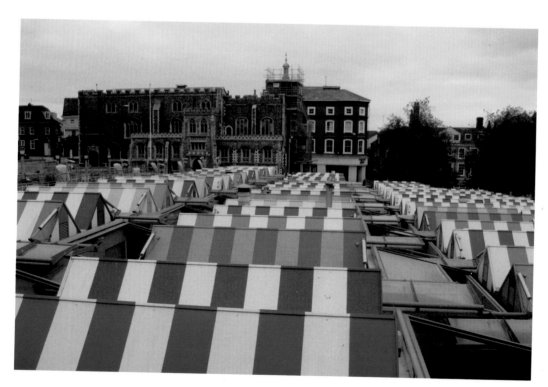

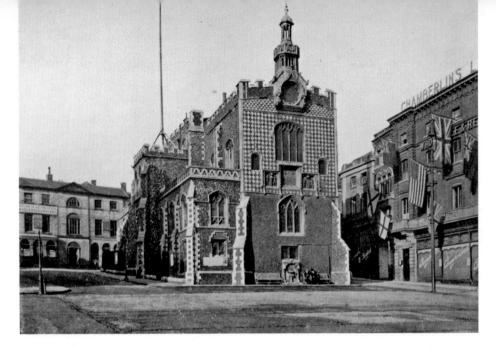

The Guildhall

Norwich became a county in its own right by a royal charter of 1404. To celebrate their new powers the citizens built this imposing new edifice, which contained law courts, and the basement served as the city prison. A century ago, some city officials questioned whether it was worth preserving; fortunately, the Guildhall has survived and has become one of the city's most-loved buildings.

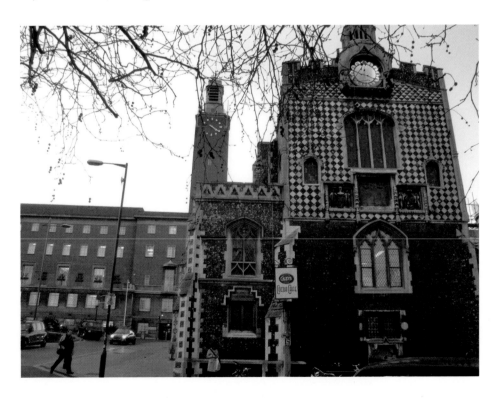

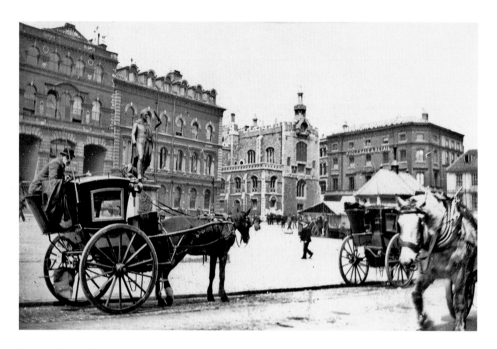

Sunday Morning

Cabs wait in the Market Place, with the stalls cleared away. The statue is that of the Duke of Wellington, erected here in the Market Place in 1851. It was moved into the Cathedral Close in 1937, just before the opening of City Hall. Wellington can still be seen in the Close, opposite the more well-known statue of Admiral Nelson. Today, the stalls are permanent, and some open on Sundays.

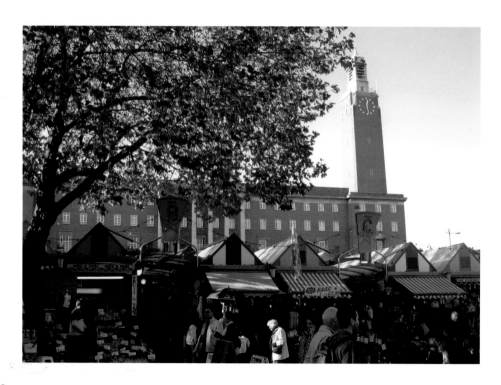

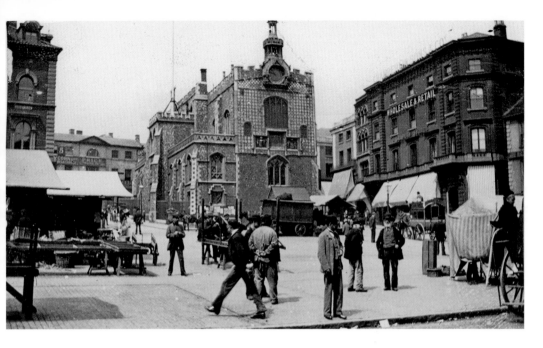

Amateur Photography

This and the previous photograph are among five in this book taken by Revd William Pelham Burn, rector of Saint Peter Mancroft, an amateur photographer and also a keen mountaineer; he had to travel a very long way from Norwich to satisfy the latter passion. Saint Peter Mancroft, the market church of Norwich, is visible in several images in this book.

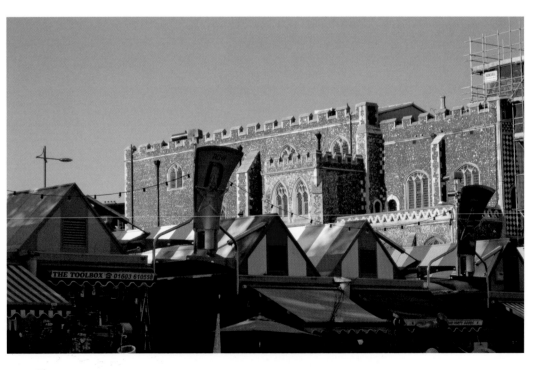

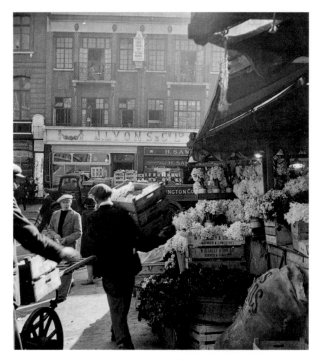

More Than Just Food

The market has always had a wide range of products for sale, as well as locally produced fruit, flowers and vegetables. The historic photograph shows two traditional shops: the jewellers, H. Samuel, still flourishing on Gentlemen's Walk, and also a tea shop run by J. J. Lyons and Co, long defunct but still a happy memory to older shoppers.

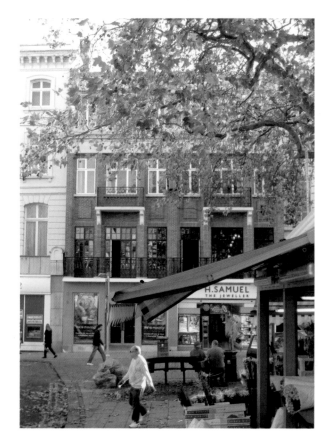

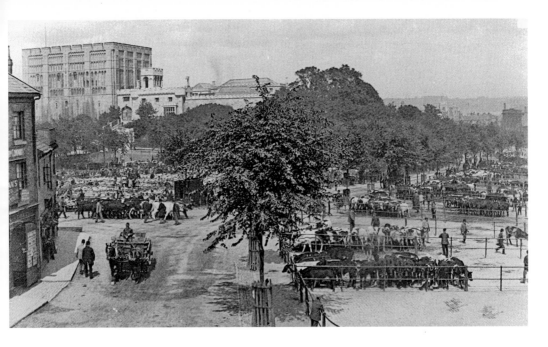

The Cattle Market

The two markets of Norwich stood for centuries on either side of the castle, like two lungs breathing life into the city. The cattle market literally brought life into the heart of Norwich: cows, sheep, pigs and poultry were brought here along all the main roads into the city. Like any good market, it was surrounded by public houses, some of which still flourish despite the disappearance of the market traders.

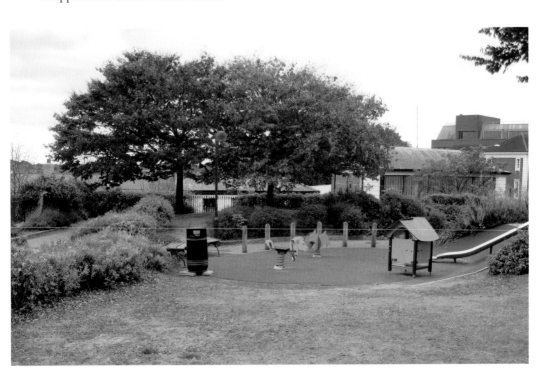

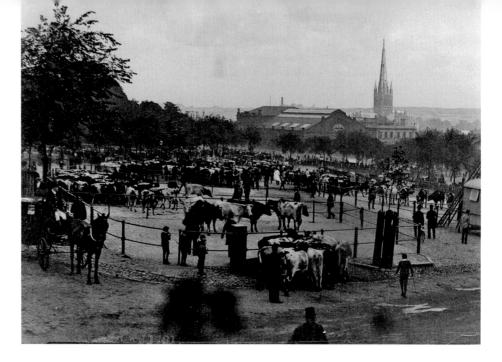

From the Golden Ball

The historic photograph was taken from the upper window of the Golden Ball public house, now replaced by the offices of Eastern Counties Newspapers, and the statue in front of their building is indeed representative of the earlier name. In the distance is the back of one of Norwich's finest Victorian buildings, the Agricultural Hall, built in 1882 by J. B. Pearce.

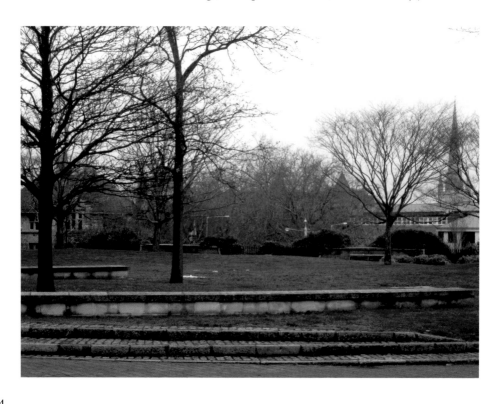

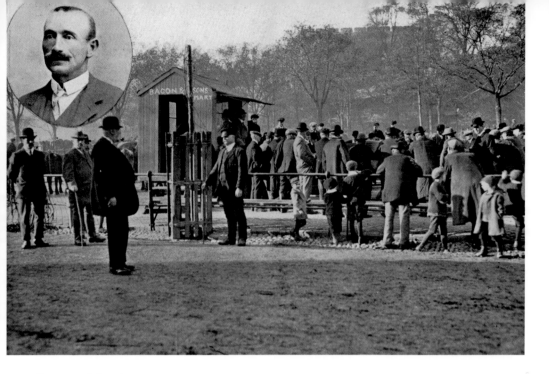

Bacon and Sons'

The auctions on the cattle market were lively affairs and much enjoyed by local children; Bacons' was established in 1873. The cattle market closed down in the 1960s and has been replaced by the Castle Mall shopping centre, most of which is below ground level with a public park above it. The park includes a section little known even to Norwich residents, with examples of modern sculpture.

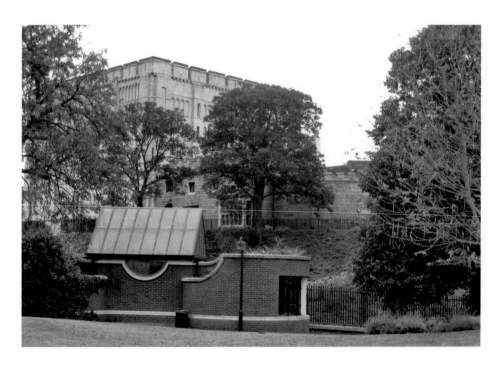

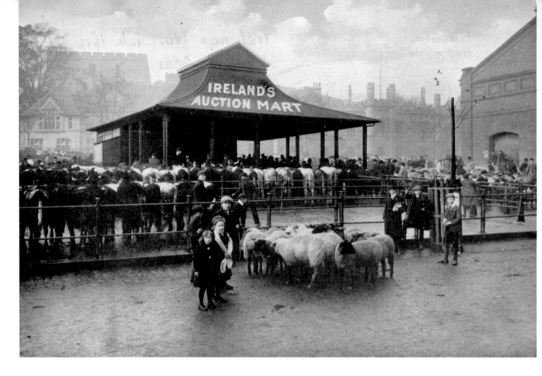

Ireland's Auction Mart

The cattle market was held in the castle bailey or ditches for at least four centuries. There were also public hangings here, such as those of the citizens of Norwich convicted of riot in 1648 during the Civil War between Royalists and Parliamentarians. Witches have also been hanged here. After such a troubled past, the whole area is now one of the most restful in the city.

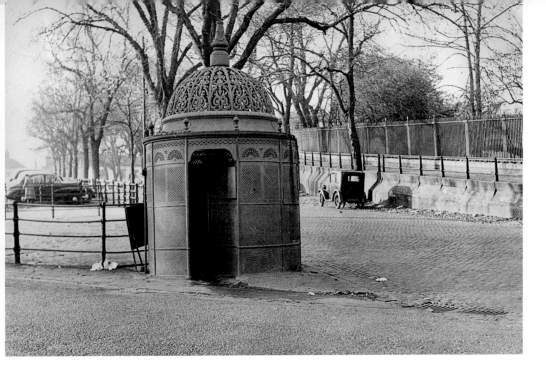

Cattle Market Convenience

These cast-iron urinals were once fairly common in the city: another can be seen in chapter six. Both have gone long ago, but there are still two fine urinals to be seen in Norwich: the flint and brick one on Saint Andrew's Plain and the pre-cast concrete one on Barn Road. However, be warned that neither is currently in use.

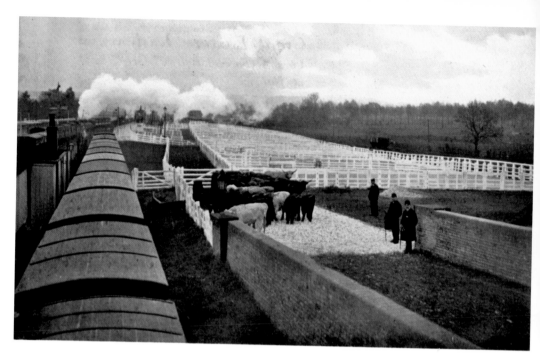

Trowse Cattle Accommodation

A large quantity of livestock — up to 4,000 beasts in a single day — came by train to Trowse where there were six acres of pens. They were then herded through town, along either Ber Street or King Street. There are many stories of escapes, including an occasion when a cow got away from its master — and stopped play at the cricket ground on Bracondale!

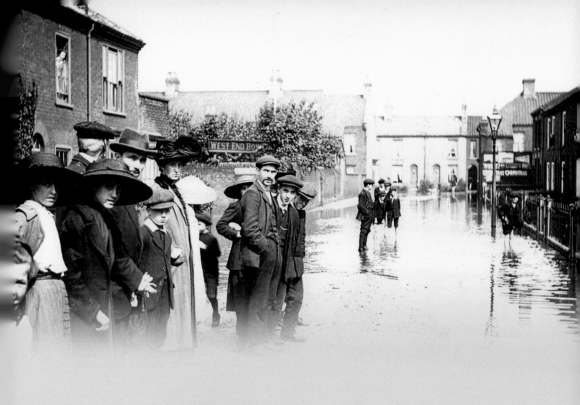

CHAPTER 2

The Great Flood of 1912

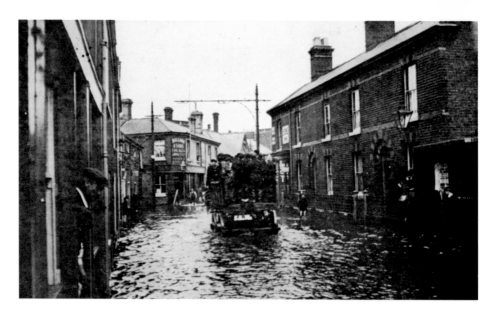

Barn Road

The river has given Norwich its life, as we shall see in the next chapter of this book, but it can also be the cause of disaster. There have been many floods in the city throughout the centuries. The photographs in this chapter are of the last great flood, that of 25-26 August 1912.

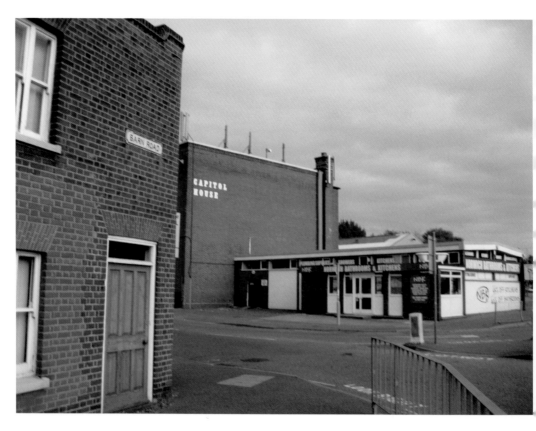

Westwick Street

Those August days in East Anglia in 1912 saw probably the heaviest rainfall event ever to occur in the area, with some places experiencing 200mm (7-8 inches) of rain in 24 hours. The flood level in Norwich was 15 inches higher than the previous highest flood mark ever recorded — almost exactly three centuries earlier (1614, to be precise).

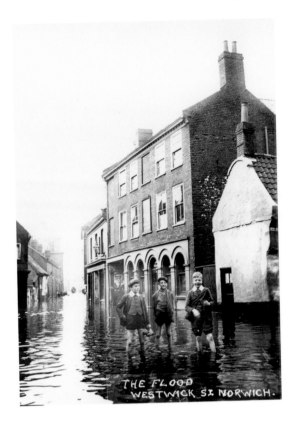

THE FLOOD
WESTWICK ST. NORWICH.

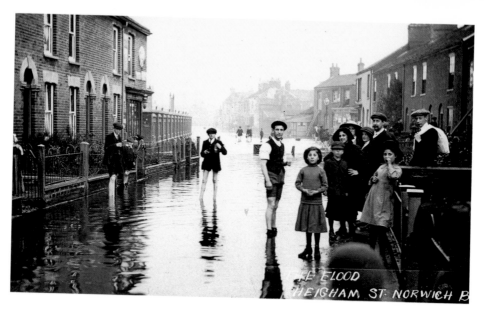

Heigham Street

The low-lying areas around Heigham Street and the Dereham Road were very badly flooded. To get an impression today of how high the flood water came a century ago, visit the church of Saint Barnabas in Heigham: there is a plaque in the church showing the high water mark of the 1912 flood.

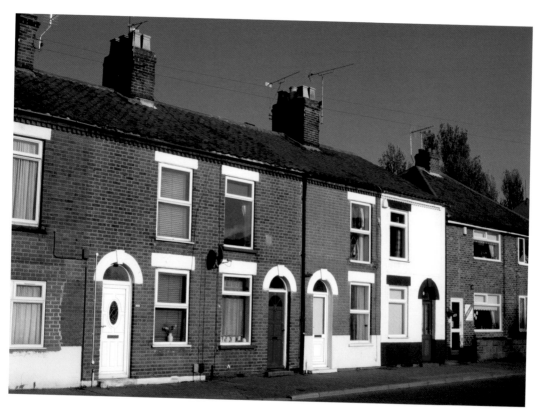

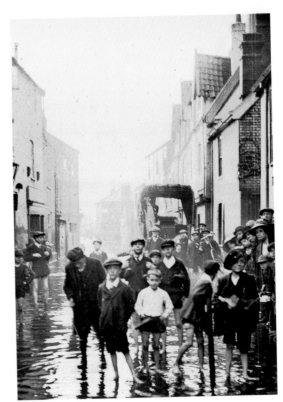

Heigham Street (*Continued*)
In the days before television, it was newspaper reporters who brought news of the floods in Norwich to the world. The London reporters were shocked by the conditions in some parts of Norwich, with up to a dozen families crowded around a yard, sharing one toilet and very basic washing facilities.

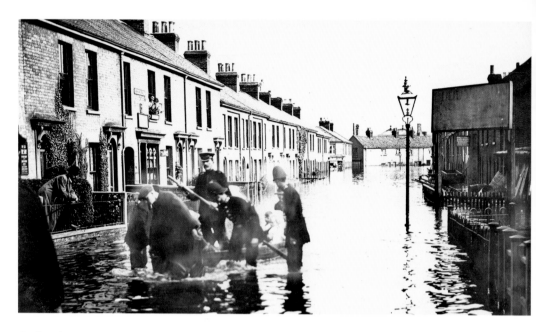

Orchard Street

The gas lamppost stands forlornly in the water; it certainly does NOT lead to the magical land of Narnia. The Victorian terraced houses in this street were swept away in the 1970s after a century of use; will their replacements last as long?

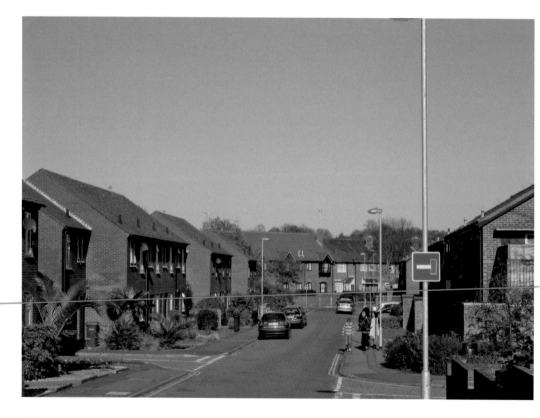

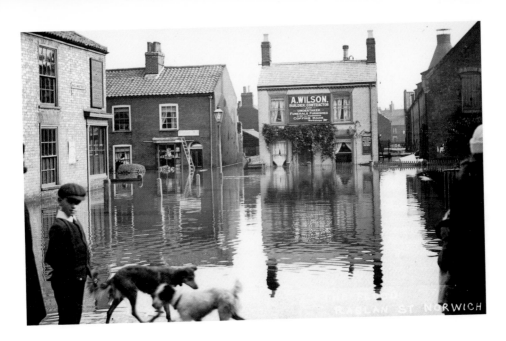

Raglan Street
Most of the houses and streets shown in the historic photographs in this chapter have disappeared, not because of the flood damage but because of bombing damage of the kind shown in Chapter Four, and the re-housing schemes that followed the war.

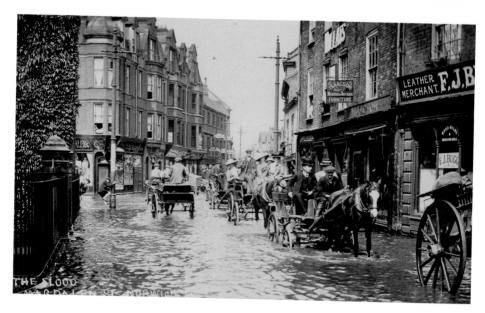

Magdalen Street

The church on the left is that of Saint Clement. This was the heart of Viking Norwich in the late ninth century. The channel of the river in the city has been widened in the twentieth century and there has been no repeat of the disastrous flood of 1912 — so far!

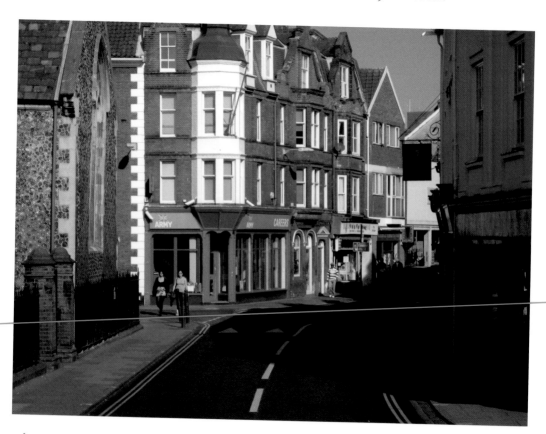

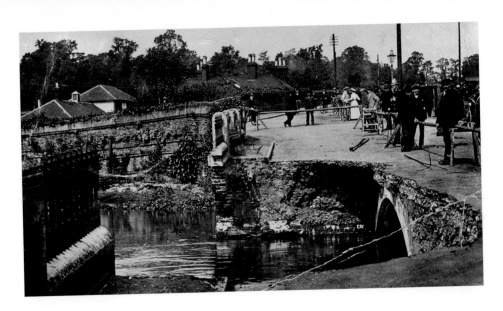

Trowse Bridge

It was not just the river Wensum that overflowed, the Yare too was dangerously overfilled and severely damaged the bridge at Trowse. The village has been much improved since through-traffic was diverted to the southern by-pass; only local traffic now passes across Trowse Bridge.

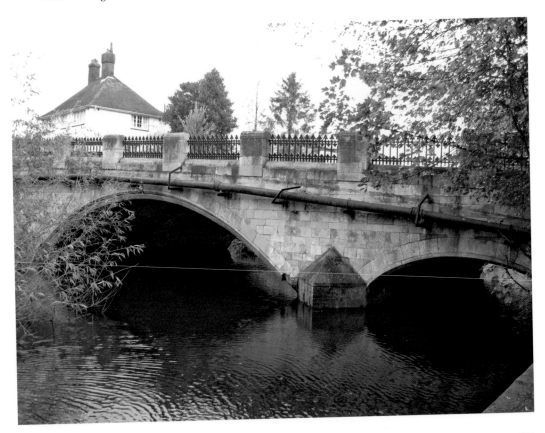

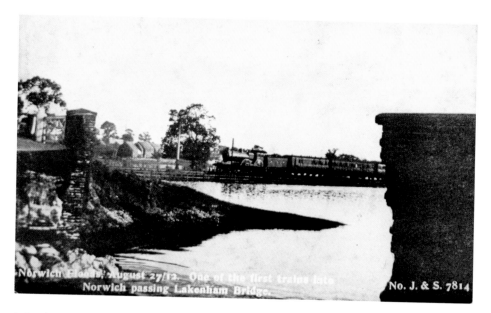

Norwich Floods, August 27/12. One of the first trains into
Norwich passing Lakenham Bridge.

No. J. & S. 7814

Lakenham Bridge

The road bridge here was completely destroyed by the force of the water in the river Yare and the branches and debris within it. There are two railway lines running through Lakenham, the line to Cambridge and the line to London, which passes across a long viaduct, a fine piece of railway architecture funded by Norwich Union boss Samuel Bignold.

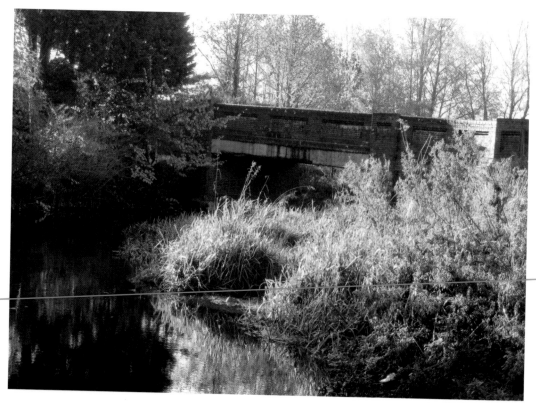

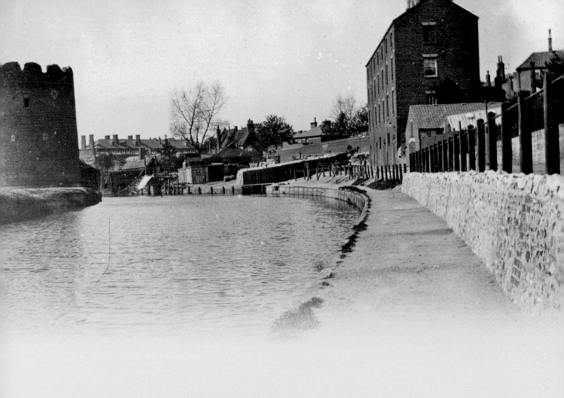

CHAPTER 3

A Walk Along The River

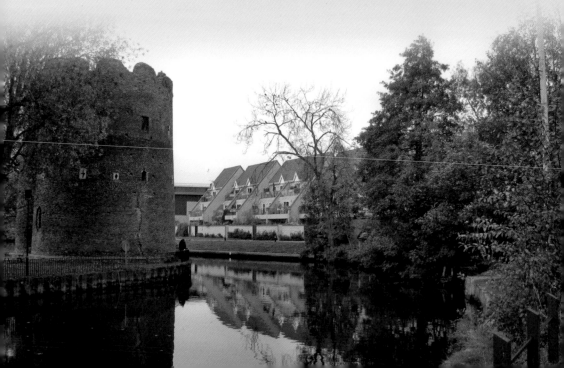

Bishop Bridge

Inns and bridges have always gone together, and the Red Lion still stands beside Bishop Bridge. Built in the fourteenth century, it is the only surviving medieval bridge in Norwich and probably the oldest bridge in Britain still in daily use, although now closed to cars. The gas holders across the river are on the site of the Lollards' Pit where devout Norwich citizens sacrificed their lives for their religious beliefs half a millennium ago.

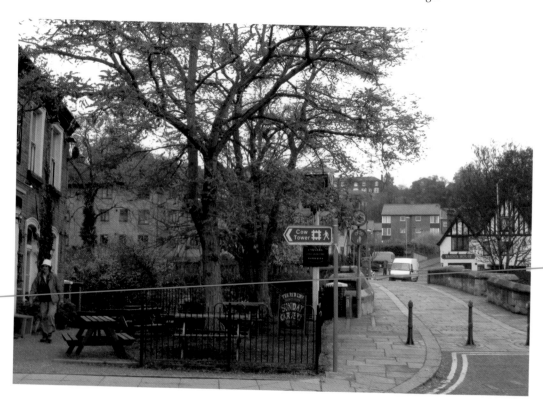

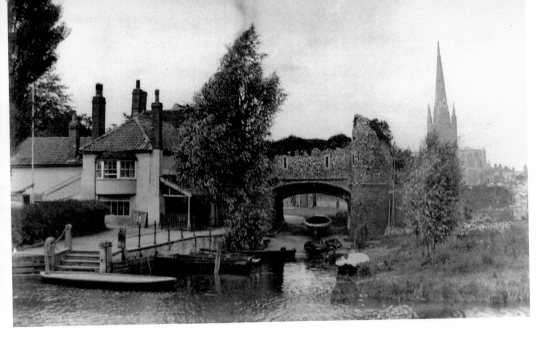

Pull's Ferry

Further downstream, Pull's Ferry is one of the most painted and photographed spots in the city. There was originally a canal running underneath the arch; the stone of which the cathedral is built was transported all the way from Normandy by sea and river. Pull is actually the name of the ferryman in late Victorian times, as before his time the ferry was called Sandling's Ferry after the ferryman during the reign of the first Queen Elizabeth!

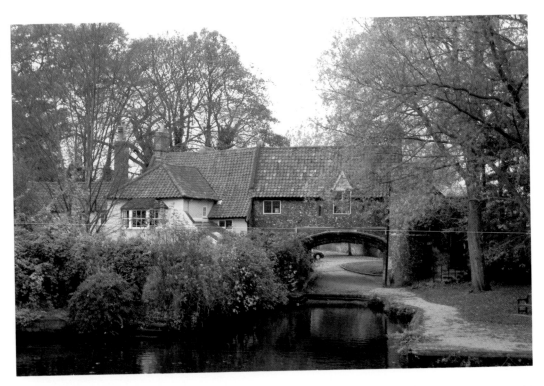

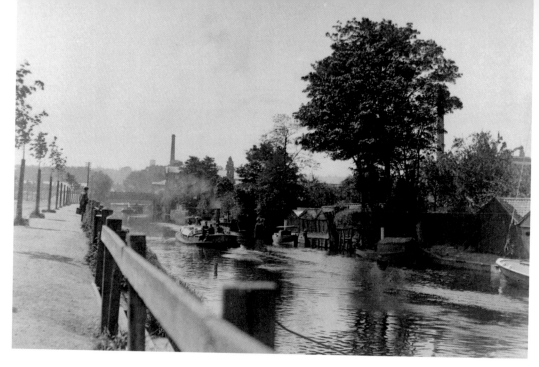

Riverside

We are on the opposite bank from Pull's Ferry, looking downstream. Foundry Bridge can be seen in the distance, first built in 1812 but much busier after Thorpe station opened on the left bank in 1844. The historic photograph shows beyond it the tall tower of the iron foundry that gave the bridge its name. Norwich Yacht Club now occupies the left bank, the upper limit of navigation for Broads cruisers.

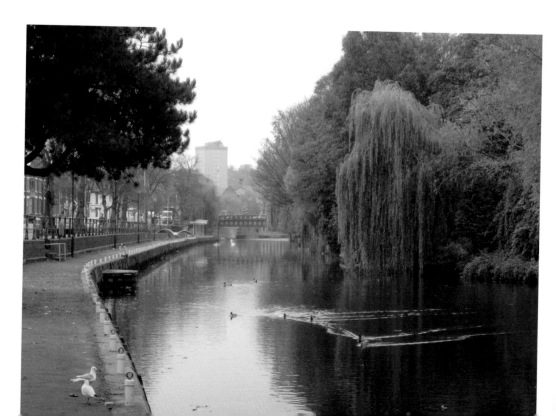

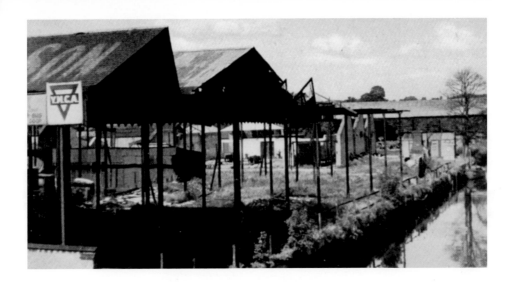

From Foundry Bridge
Looking upstream,
we can see the timber
yards on the bank,
already derelict at the
time of the historic
photograph. The City
Council has for many
years had the excellent
idea of opening
up the river as the
properties along it
are redeveloped. This
was the first stretch
of this river walk to
be opened, and these
willows were planted
in the 1970s.

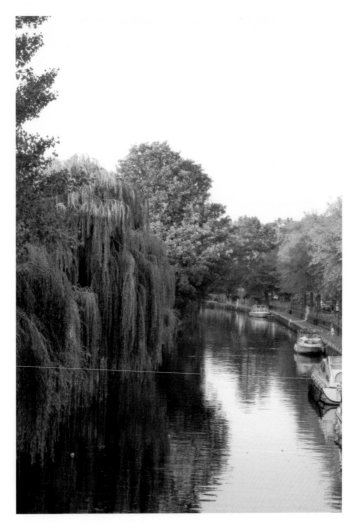

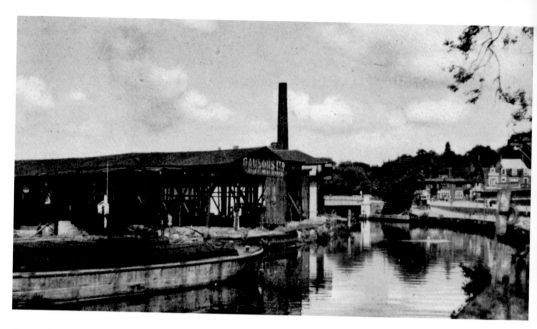

Towards Foundry Bridge

Again, looking upstream, the iron foundry chimney dominates the historic photograph. The left bank is now occupied by the Premier Inn Nelson Hotel, while the right bank has seen the recent development of apartments and entertainment facilities on the large riverside site formerly occupied by the engineering firm of Boulton and Paul. The river itself is now much cleaner that it used to be and a much more pleasant natural habitat.

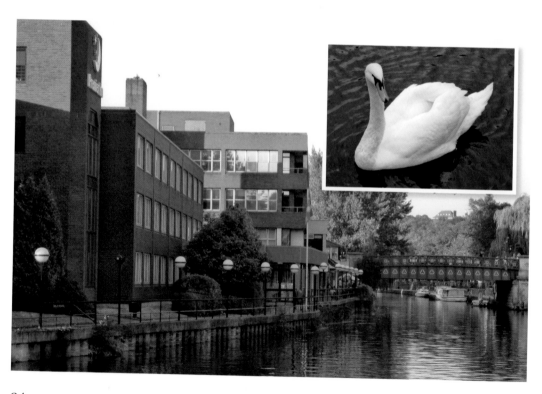

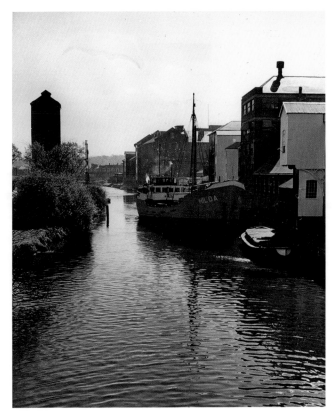

'Norwich a Port'
Norwich has depended on
the river for its trade for a
thousand years, and even in the
1950s and 1960s boats as large
as this would bring cargoes up
the Wensum. Today, this traffic
has almost totally disappeared,
but the new pedestrian bridges
across the river — the Novi
Sad and Lady Julian Bridges —
are able to swing open should
large ships again visit the city.

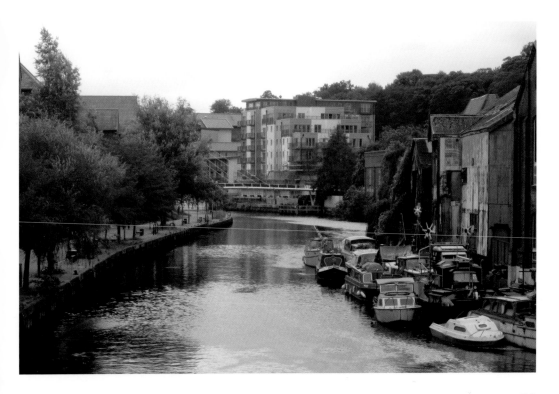

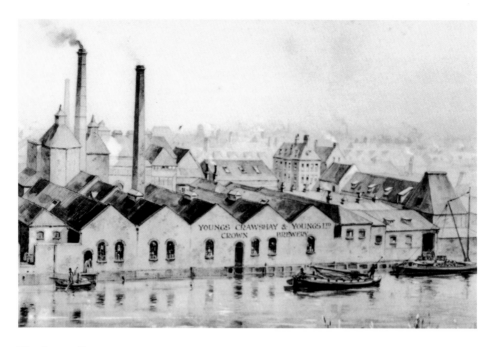

The Crown Brewery

There were four large breweries in Norwich in the nineteenth century and the river was a key element in their existence for the carriage of malt and barley. The Crown Brewery has given way to Wensum Lodge, a centre for adult education, while one of the maltings has been successfully converted into apartments. The entrance gates to Wensum Lodge still bear the emblem of the Crown Brewery on their gateposts.

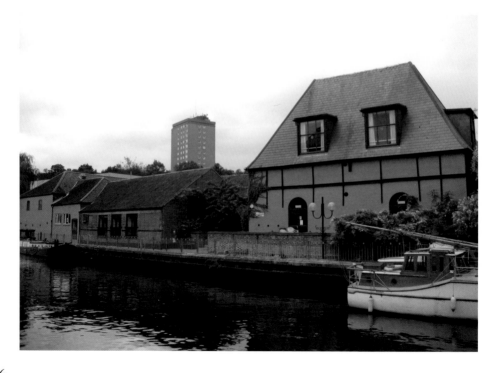

Thorpe Old Hall

Downstream of Norwich is Thorpe. One of its highlights is this house, which is shown on a map of 1589, when it belonged to a member of the Paston family. They also had a house in Elm Hill in the centre of Norwich, which was then, as now, ideally reached by boat from Thorpe. There is a plan to build a new footbridge here to allow easier access to the country park at Whitlingham on the other side of the Yare.

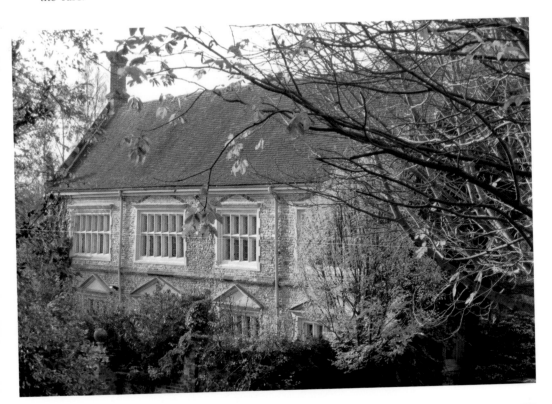

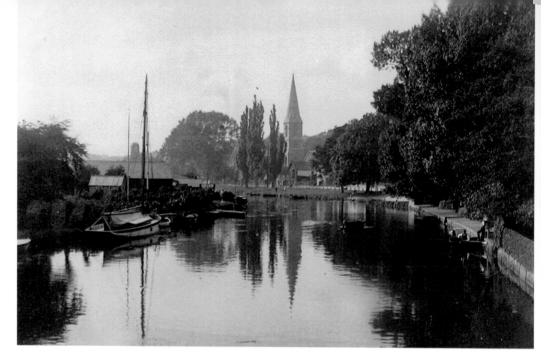

Thorpe Saint Andrew

Looking upstream towards Thorpe church, which was built by Thomas Jeckyll in 1866. The medieval church that his new building replaced now acts as its entrance porch, as he intended. The spire he designed for his new church proved to be expensive and was not built until after his death. In the long term it was shown to be over-ambitious, and after the Second World War the church was given a more modest spire.

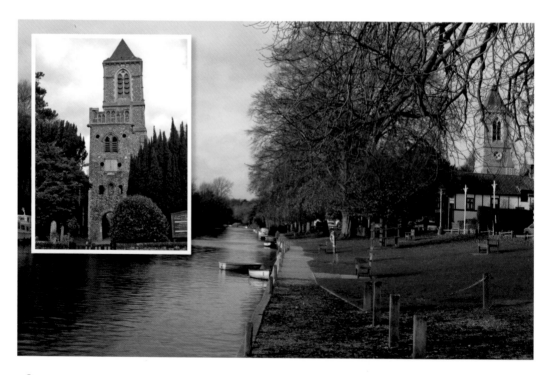

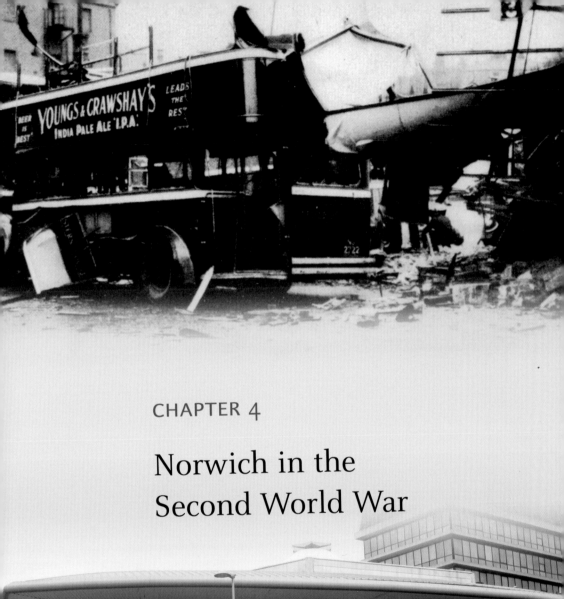

CHAPTER 4

Norwich in the
Second World War

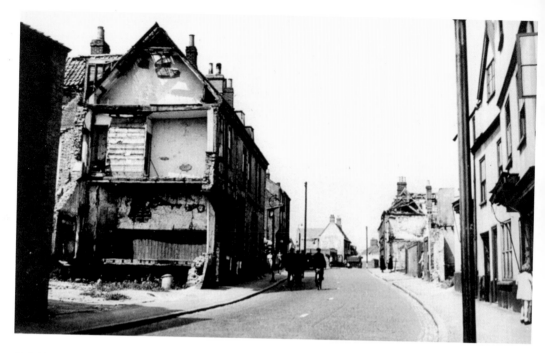

Oak Street

The historic photograph was taken by an American in active service at one of the Norfolk airbases, just one of a rich photographic archive belonging to the American Memorial Library in Norwich, and held at the Norfolk Record Office. Many Norfolk people still remember the generosity of these visitors from across the sea during the lean years of the Second World War.

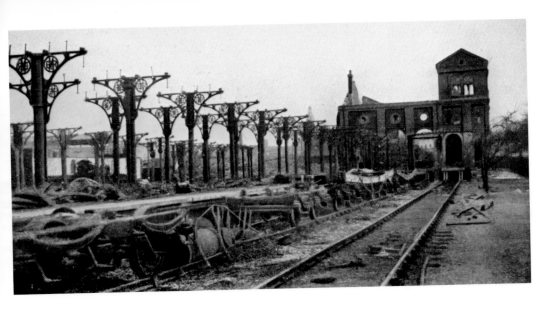

City Station

Stations were an obvious target for bombing raids; there is a plaque at Thorpe station to the twelve railway-men killed in air attacks while working there. City station was rebuilt after the war but closed in 1959. Now the car reigns, but there is a very pleasant walk behind the retail stores, following the old railway line beside the river.

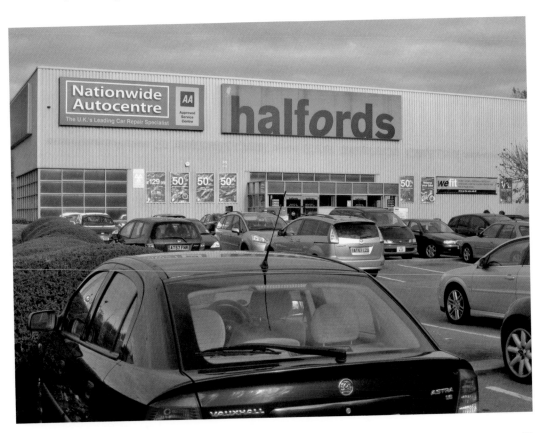

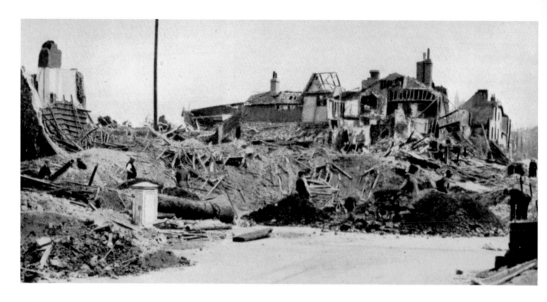

Saint Benedict's

The area where St Benedict's meets Grapes Hill was perhaps the part of Norwich that was worst hit during the war, especially by the attacks on 27-28 and 29-30 April 1942. Norwich was one of the cities chosen by the Germans because it was highly praised in Baedeker's guidebook, and for this reason these raids are often called the Baedeker raids. The devastation created an opportunity for large-scale reconstruction.

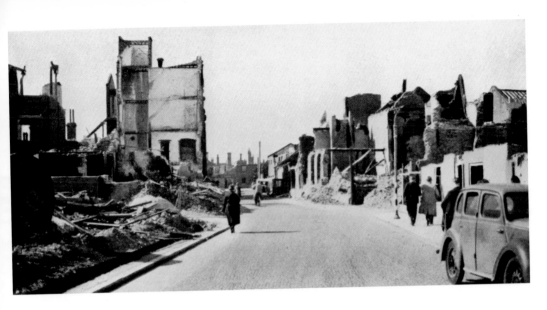

Westwick Street

Devastation in the Westwick Street area included the loss of the Coleman's factory making the tonic drink 'Wincarnis', as well as many houses and shops. Post-war redevelopment plans have involved creating a walk along the inside of the medieval City Wall — and the building of the inner ring road immediately outside it!

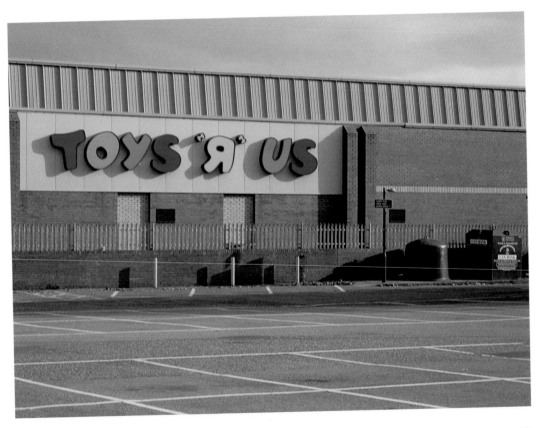

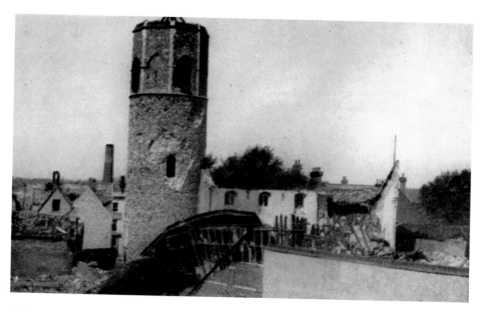

Saint Benedict's Church

The Church of Saint Benedict was one of several inner city churches destroyed or badly damaged in the war. Others included Saint Paul, Saint Michael at Thorn and Saint Julian. Only Saint Julian was rebuilt; the tower of Saint Benedict now stands alone in a modern housing estate. It is a *round* tower, and these are so common in East Anglia that local people do not always appreciate how unusual a feature a round tower is.

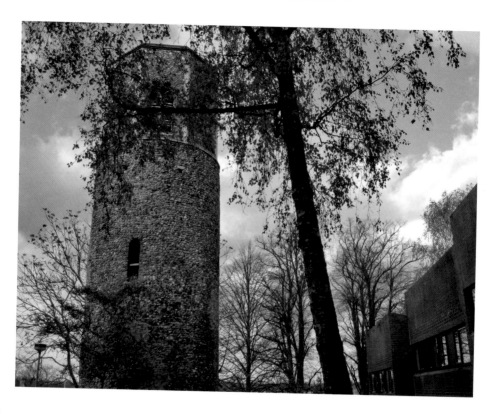

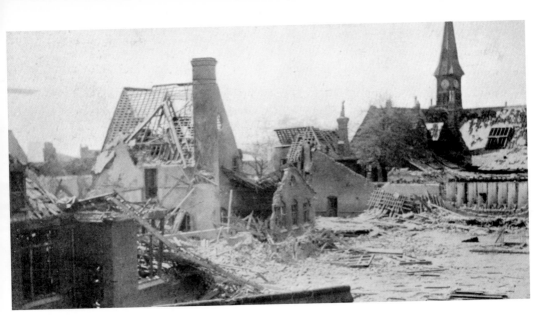

Saint Augustine's School

The school was destroyed in the air raid of 27 April 1942. Very luckily, the raid was at night so that the school was empty when the bombs fell. Many older Norwich people remember, as children, arriving here the next morning only to find their school bombed and out of action, but the education authorities soon found alternative accommodation for them!

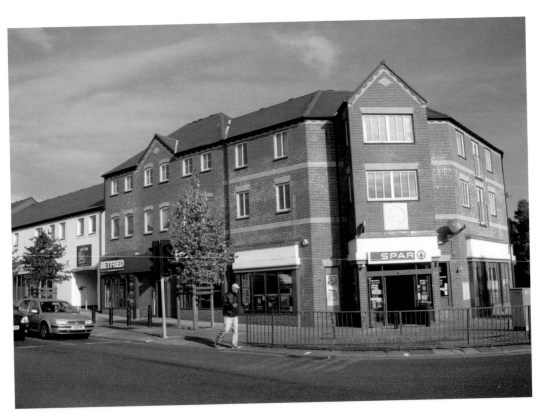

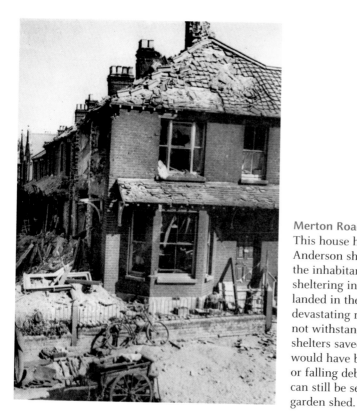

Merton Road

This house had cellars rather than Anderson shelters, which was fortunate: the inhabitants of the house were sheltering in the cellar when a bomb landed in the front garden with devastating results. Although they could not withstand a direct hit, Anderson shelters saved the lives of many who would have been killed by flying glass or falling debris; the occasional shelter can still be seen, usually put to use as a garden shed.

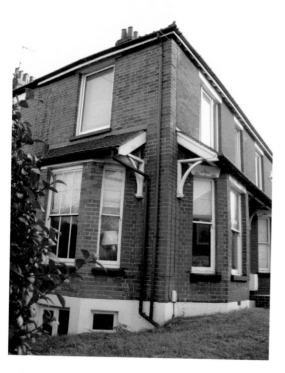

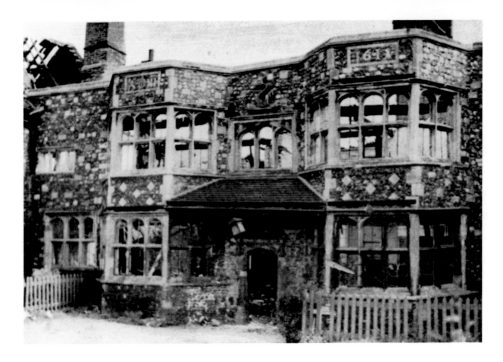

The Dolphin

The Dolphin was badly damaged during the first Baedeker raid, on 27-28 April 1942, but has since been lovingly restored. The building has a long history: it was used as a residence by the Bishop of Norwich, Joseph Hall, when he was evicted from his palace in the Cathedral Close by the Parliamentarians in 1647. This is why the nearby street is called Old Palace Road.

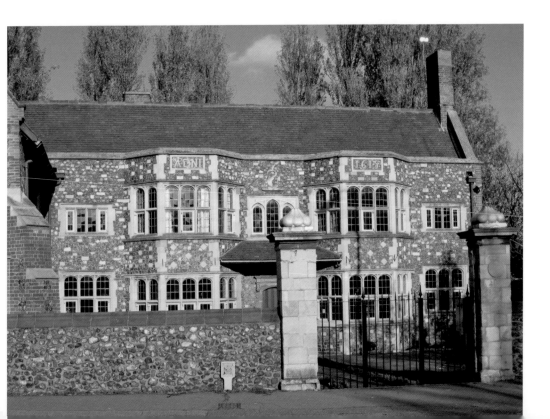

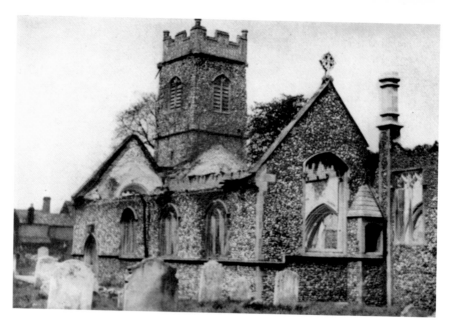

Saint Bartholomew, Heigham

Saint Bartholomew was one of the churches in the suburbs that were badly damaged in the Baedeker raids, along with Saint Thomas on the Earlham Road and Saint Anne, Earlham. The Bishop previously mentioned, Joseph Hall, was buried here, but his tomb was destroyed in the air raid. As with the church of Saint Benedict, the tower of Saint Bartholomew's now stands alone.

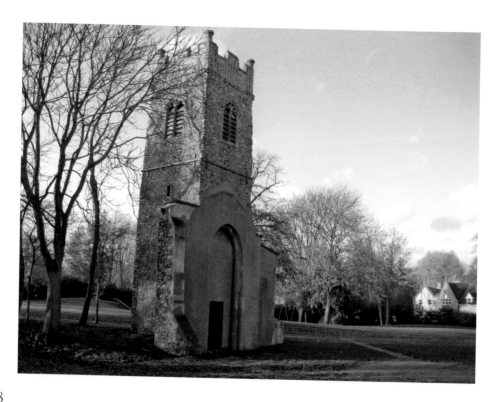

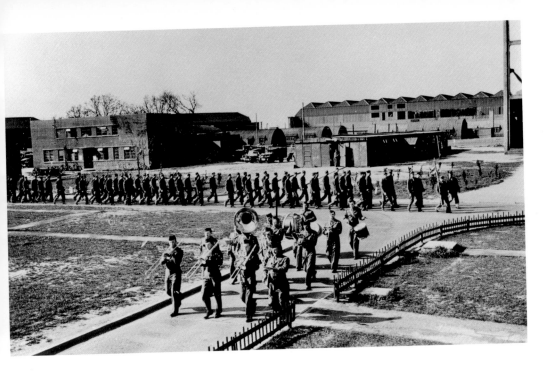

Horsham Saint Faith

The first aerodrome in Norwich was on Mousehold Heath, originally a test base for Boulton and Paul planes in the First World War. Horsham Saint Faith was one of the many bases in East Anglia used by the United States Army Air Force during the Second World War, and nearly 7,000 young American servicemen died in missions from these bases. After the war, the base at Horsham became the new Norwich airport as it is today.

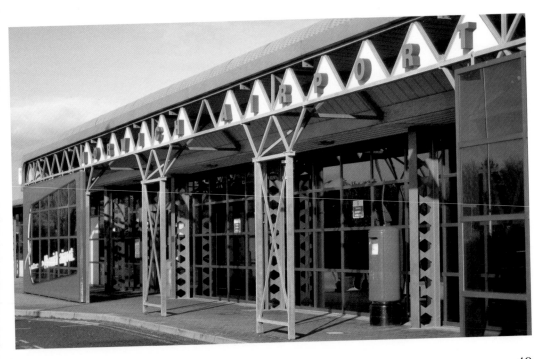

CHAPTER 5

Shopping in Saint Stephen's and Chapelfield

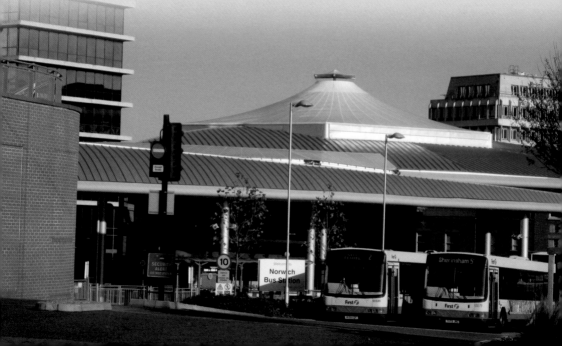

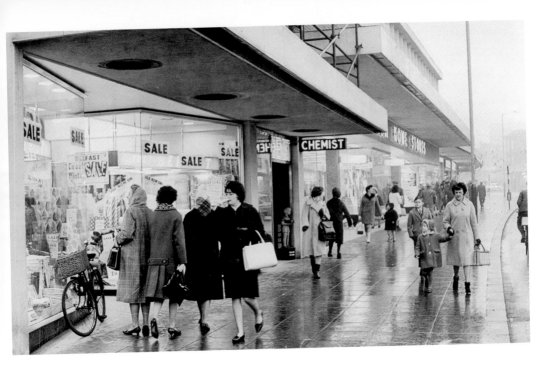

'Shop 'til you Drop'

Saint Stephen's was a narrow street, which in the early twentieth century was filled by the trams running through it, and which had old buildings on both sides. It was severely damaged by bombs and it was decided to clear away all the buildings on the bus station side and create a dual carriageway, to bring cars into the heart of the city. Thoughts have changed and it is now intended to make the street bus-only.

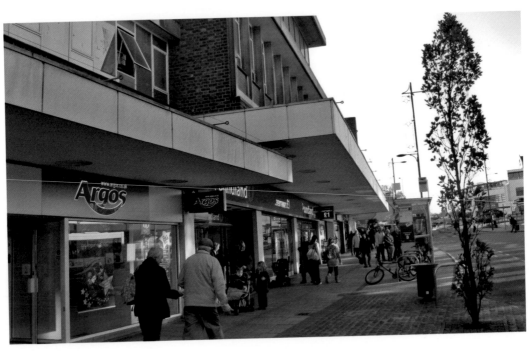

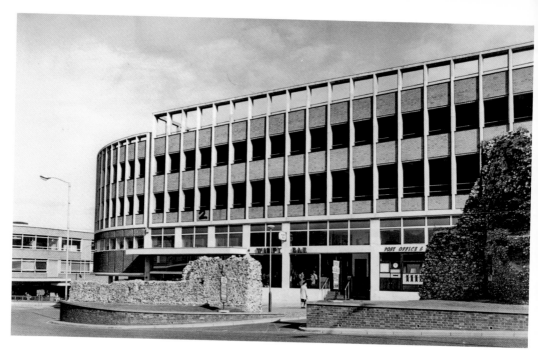

At the Top of the Street

The car park at the top of Saint Stephen's is on the inner ring road and intended to provide easy access to the shops for people from the suburbs and the county. It is still very popular, but the two facilities in the historic photograph — a Wimpy bar and a local post office — are very much features of the past. Most of the units here are now taken over by charity shops.

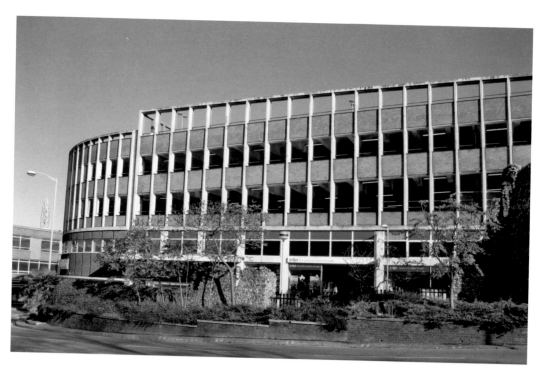

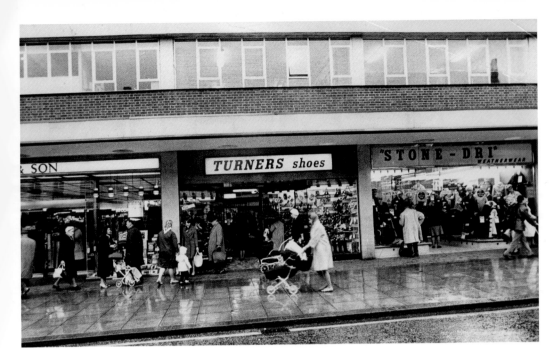

Forty Years of Shopping

Shopping in Saint Stephen's on a wet day in the 1960s, and the pram is just giving way to the buggy. The City Plan of 1945 did not see that this street would be a major shopping area, saying, 'the popularity of this street as a shopping centre was waning before the war, and its future use as such must be discouraged'. Today, it is one of the busiest shopping streets in Norwich!

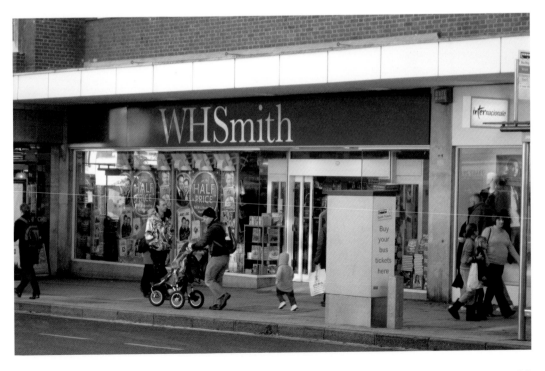

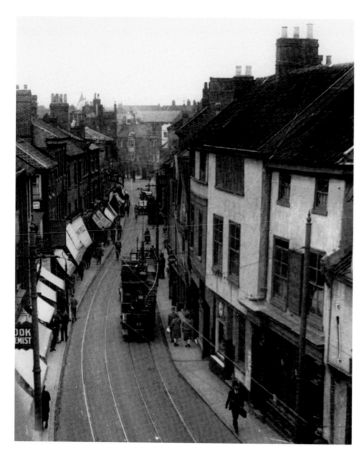

Norwich's Front Door
It is hard to imagine now how narrow Saint Stephen's used to be. For centuries, this was the 'main' entrance to Norwich for people coming up from London; Queen Elizabeth and her entourage came his way in 1578, but she would not recognise it today! However, an image of St Stephen's Gate in moulded concrete can be seen nearby, on the wall of the Coachmakers' Arms.

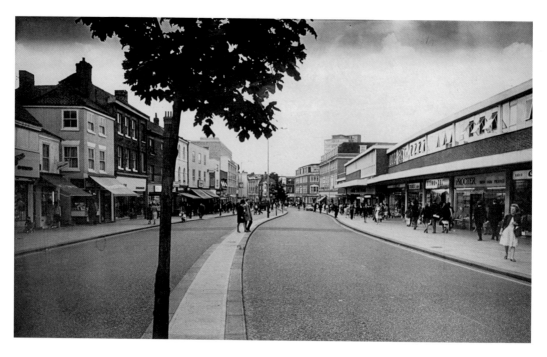

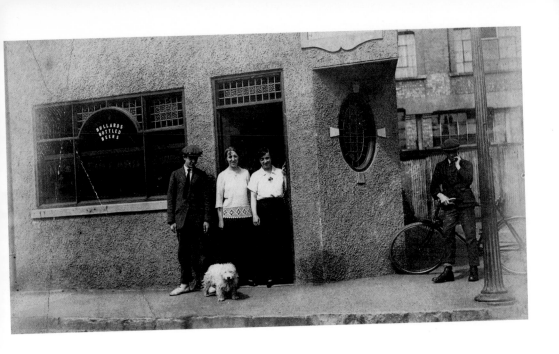

From Public House to Shopping Centre

This is the William IV public house in Coburg Street between Caley's chocolate and mineral water factory and Queen's Road. The upper photograph was taken in about 1910. In 1955, as the lower photograph records, the pub was demolished to make way for an expansion of Caley's factory, which had been taken over by Rowntree Mackintosh. The tall factory chimney was one of Norwich's landmarks.

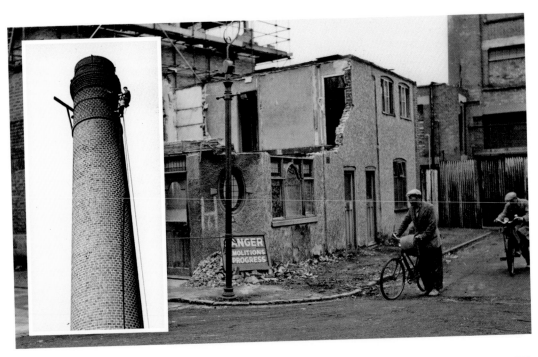

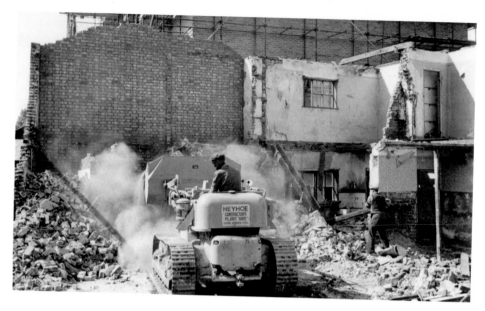

From Public House to Shopping Centre (*Continued*)

A bulldozer gives the *coup de grâce* to the William IV, after over 120 years of use. The destruction of Coburg Street opened up views of the medieval city wall, against which the houses had been built). The chocolate factory, by now owned by Nestlé, closed in 1996, as manufacturing has given way to retailing. It has been replaced by the new Chapelfield Shopping Centre. As with the older Castle Mall shopping centre, there is a great deal of history behind — and underneath — the contemporary façades.

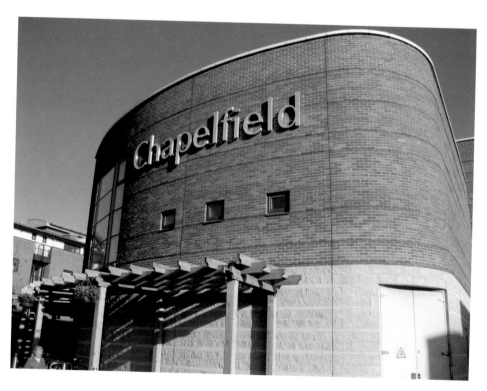

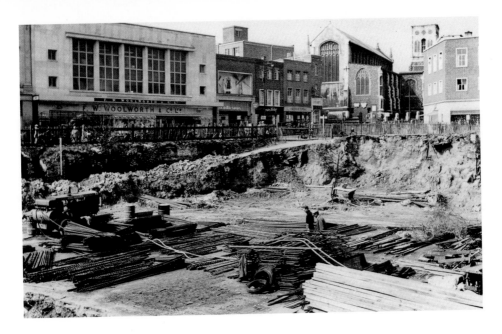

From Curl's...

Curl's was one of the best-known department stores of pre-war Norwich. It was completely destroyed by bombs in the Second World War, and the site was then used as a giant water tank for emergency use in case of incendiary bombs falling nearby. The site also proved an ideal temporary hockey stadium during Scouts' Week!

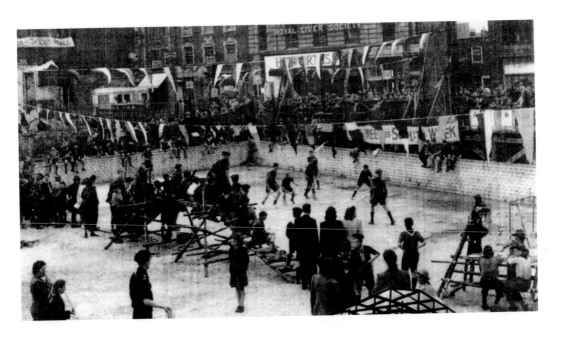

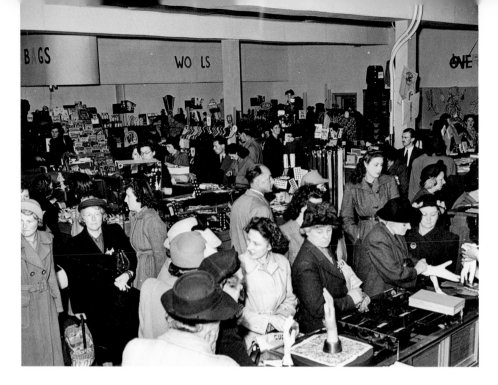

... To Debenham's

Curl's was in temporary premises, as shown in the historic photograph, until it was rebuilt in 1955 as a state-of-the-art department store. The day of the independent department store has largely passed and Curl's has becomes a Debenham's store, just as Bond's has become part of the John Lewis empire. In today's Norwich, only Jarrold's retains its independence.

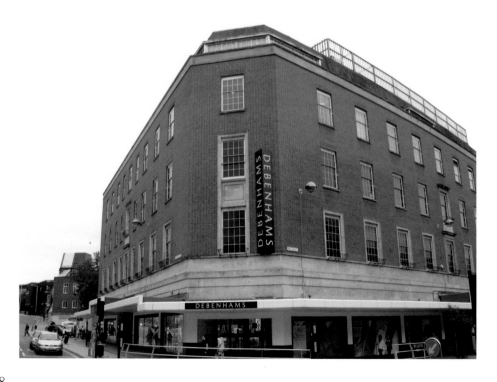

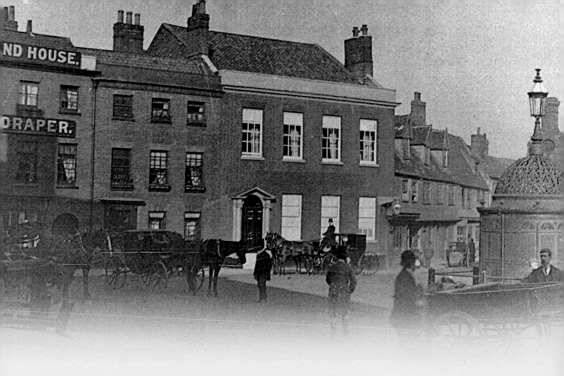

CHAPTER 6

A Walk North from Tombland

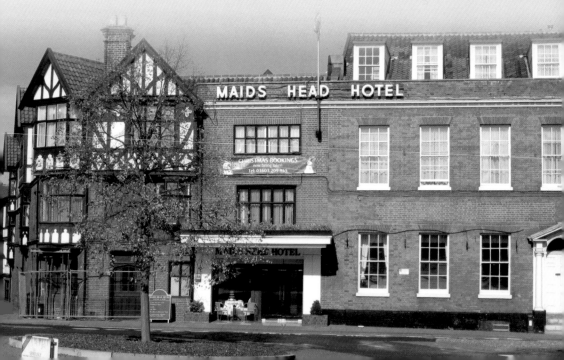

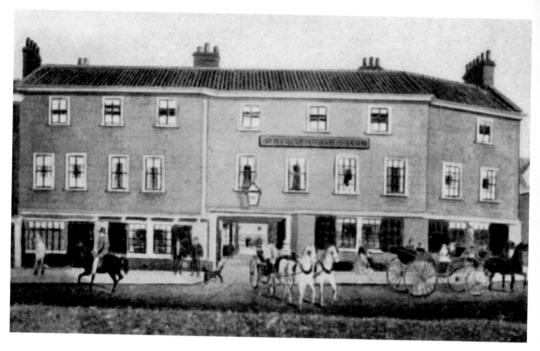

The Maid's Head Hotel

On the right as you head north, the Maid's Head is a former coaching inn and one of the oldest public houses in Norwich, and you can still drink in the coaching bar and in the courtyard, now covered over. A quarrel that led to murder took place here in 1684, the story of which is told in my *Norwich Murders and Misdemeanours* book. However, the inn is much older than this: it is mentioned in the Paston Letters written in the fifteenth century.

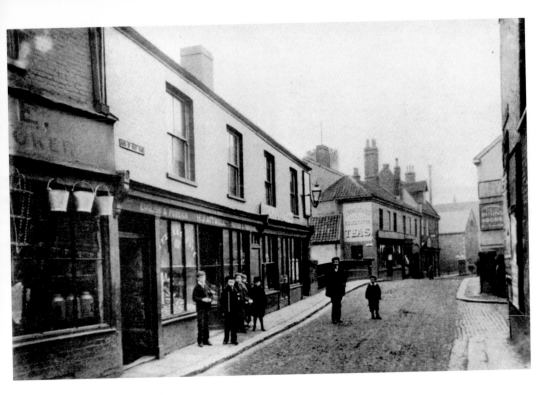

Fye Bridge Street

The river is crossed by Fye Bridge, one of the oldest crossing points in the city. Its name probably comes from the word *fyeing* meaning cleaning (the river). It needed it: in the great fires in Norwich in 1507, the flames spread across to the north part of the city on garbage that was filling up the river. The bridge in the historic photograph was replaced with a wider one in the 1930s.

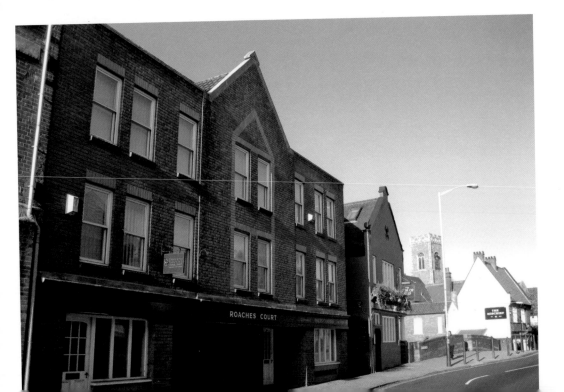

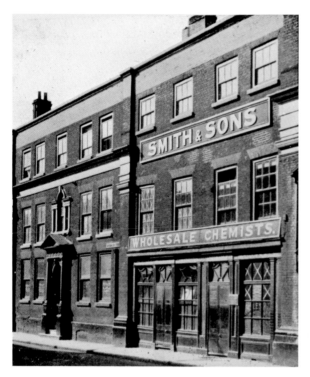

Gurney Court, the Street Front
We have passed the scene of the floods in Magdalen Street shown in Chapter Two. Seventeenth-century dormers and eighteenth-century sash windows characterise this house, one of the many fine buildings of this part of the city. The court itself is through the doorway on the right of the picture.

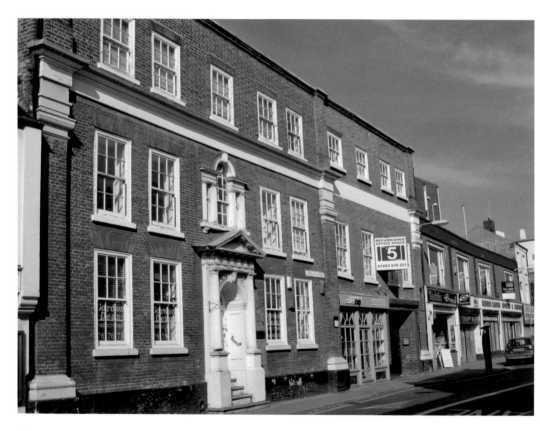

Gurney Court, the Yard

Peering through a gate into the court, one can see plaques recording the births here of Elizabeth Fry and Harriet Martineau. Elizabeth was a member of the Gurney family, prominent bankers and Quakers; they moved out to Earlham Hall when she was still a child. She later became a leading prison reformer. Harriet was a writer and also a Quaker. Both women played an important role in the abolition of the Transatlantic slave trade.

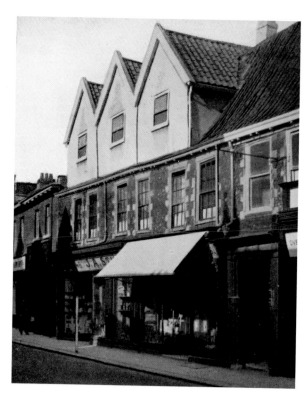

Georgian Magdalen Street
Almost opposite Gurney Court are
these wonderful Georgian houses,
described by architectural historian
Nikolaus Pevsner as 'the climax to
the street' and as 'one of the most
ornate Georgian façades in Norwich'.
They were built in about 1750,
and the interiors were completely
redesigned in the 1970s for use as
offices.

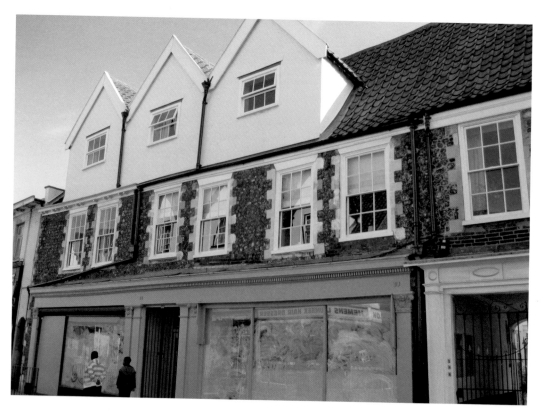

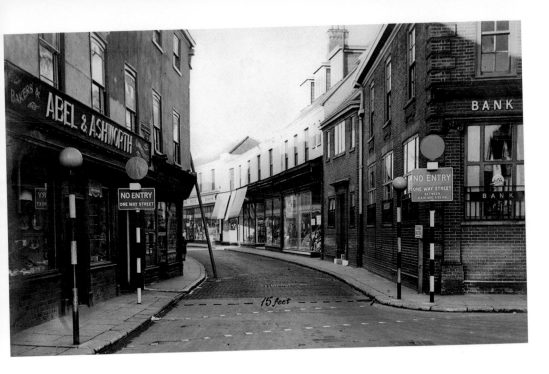

Stump Cross

Beyond the Georgian houses, the road split at Stump Cross, with Magdalen Street continuing north while Botolph Street curved away to the east. Note the belisha beacons. These were introduced in 1935, but the white stripes in the road we now associate with them did not come until after the Second World War. The whole area was swept away when the inner ring road flyover and the Anglia Square shopping precinct were built here in the 1960s.

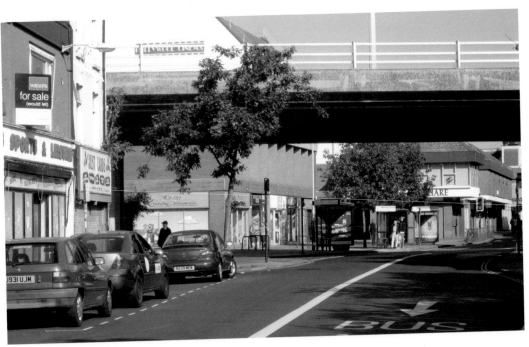

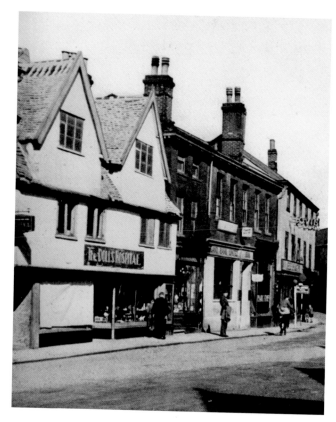

The Dolls' Hospital
Another fine building, this sixteenth-century house stood at the corner of Magdalen Street and Botolph Street and had a function hard to imagine today: favourite toys could be taken here to be mended. The houses have been replaced by the shops of Anglia Square, and the tastes of children have become far more sophisticated than they were half a century ago.

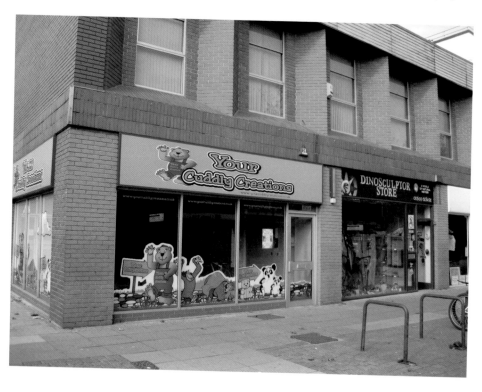

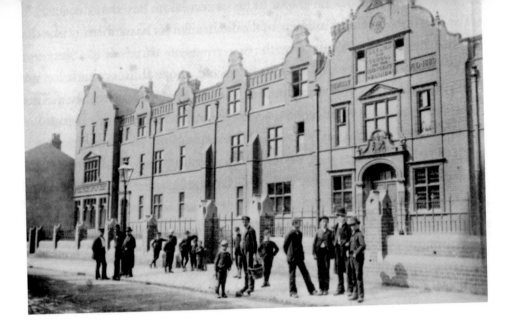

One Man's Vision

The Norwich Institution for the Blind was founded over 200 years ago by Norwich ironmonger Thomas Tawell. It has continued to offer a wonderful service for the blind and the partially-sighted, adapting to changing attitudes over the years. It is now called the Norfolk and Norwich Association for the Blind. In the nineteenth century, the main front was here on Magdalen Street, but this has been sold for new houses, and the present entrance is around the corner on Magpie Road.

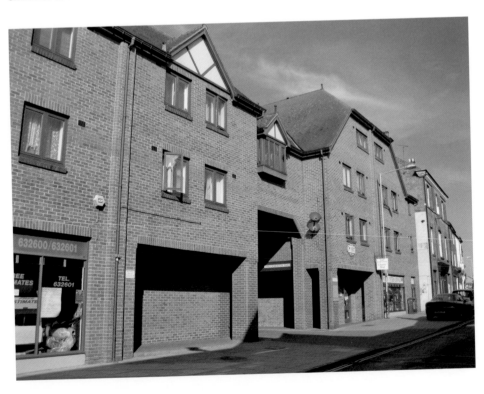

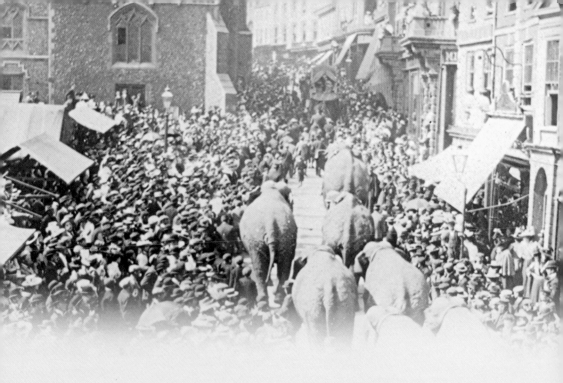

CHAPTER 7

Special Occasions

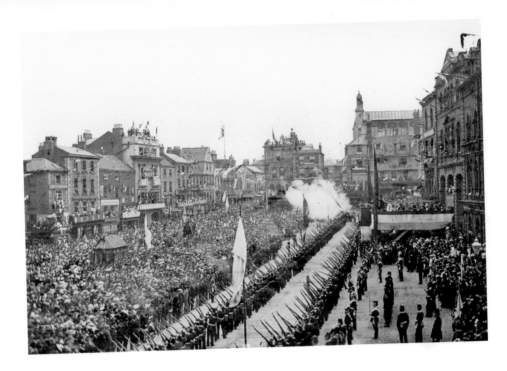

A Queen's Jubilee

Revd William Burn of Saint Peter Mancroft church was able to nip out of his place of work to photograph the celebration of Queen Victoria's diamond jubilee in the Market Place in 1897. Now that the stalls in the market are permanent, such occasions are limited to the smaller area outside City Hall.

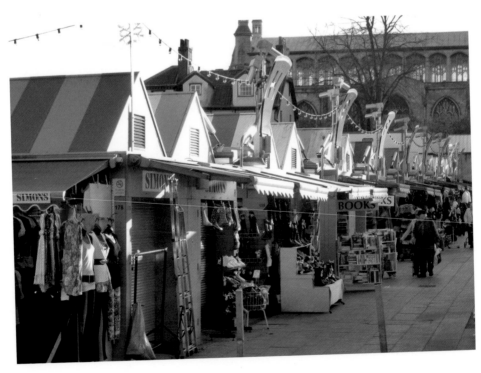

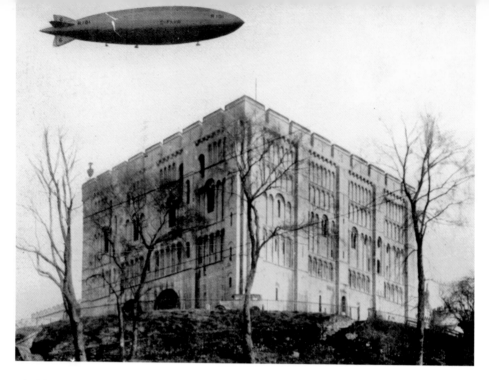

Airship over the City

The historic photograph captures the airship *R101* as she flies over Norwich on 1 November 1929. She had taken off from Pulham; the airship base there is now seen on the village sign. The urn-like object on the castle is the Norwich Time Ball. This relates to a time when clocks and watches were not so reliable as today: the ball would fall with a loud crash at an exact time every day, so that people could adjust their watches.

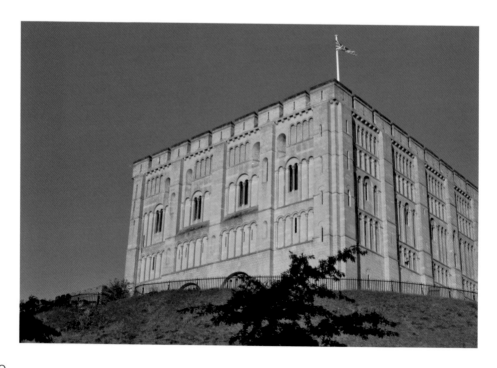

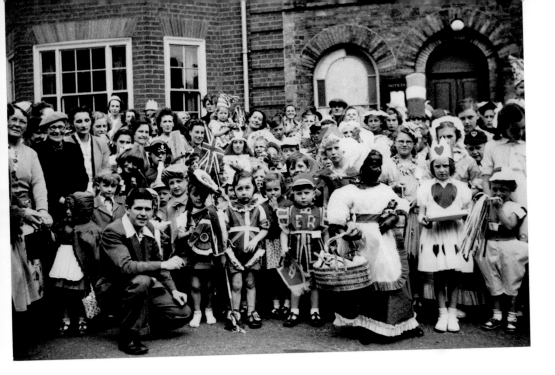

Congratulations and Celebrations

The historic photograph shows celebrations in the city for the coronation of Queen Elizabeth in 1952. One of her more recent visits to the city was to open The Archive Centre in 2003. The modern photograph needs no explanation to any resident of Norwich, but not everyone knows that the canary, the club's symbol for over a century, was first brought to the city by Dutch immigrants more than 400 years ago.

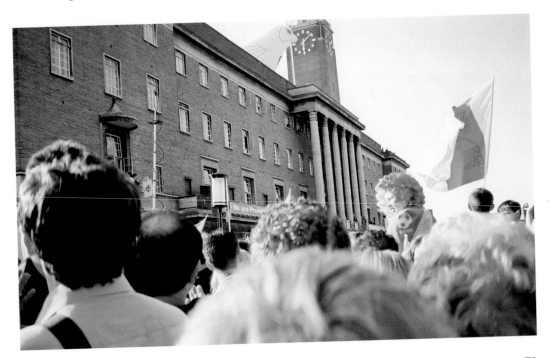

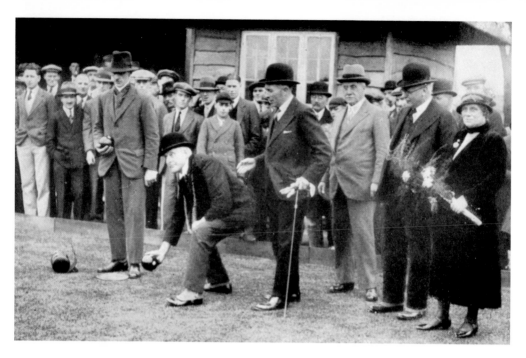

Waterloo Park

Norwich has many parks in its suburbs, several built as part of schemes to provide work for the unemployed in the 1930s. Many, like this one, were designed by the Parks and Gardens Superintendent Captain Sandys-Winsch. Waterloo Park was opened on 29 April 1933. The three monkeys on its main building represent the old motto 'See no Evil, Hear no Evil, Speak no Evil' in a very 1930's style!

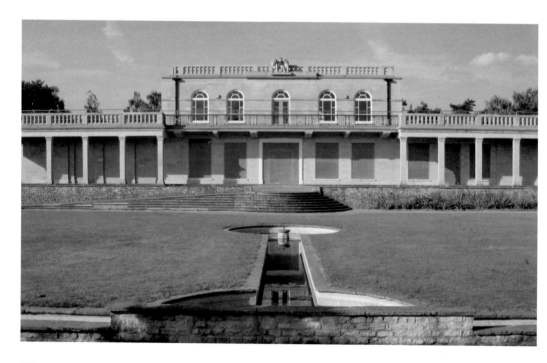

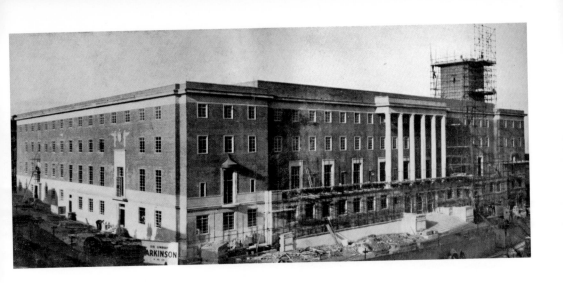

Building City Hall

Norwich's City Hall was a long time coming: it was planned at the beginning of the twentieth century but not finally built until the 1930s. The tower gives it its character, but was almost left un-built! Like all buildings of its kind, City Hall ran vastly over budget, and it was proposed to save money by omitting the tower; a large angel figure planned to surmount the tower *was* abandoned.

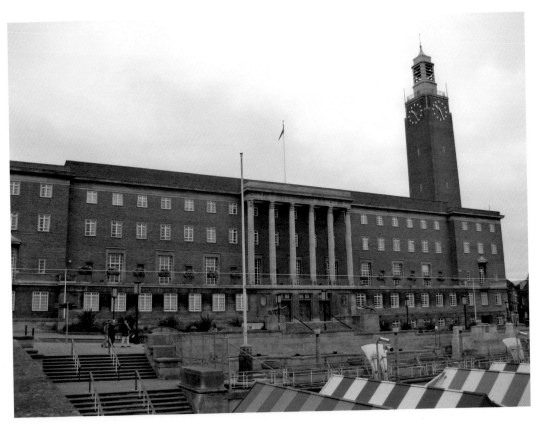

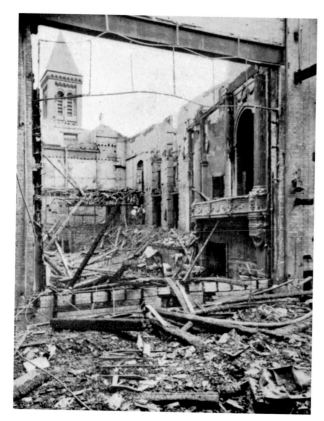

Fire at the Theatre Royal
The historic photograph shows the devastation at the Theatre Royal caused by the fire of 22 June 1934. The tower in the background is not part of the theatre but belongs to the Trinity Presbyterian Church in Chapelfield, since demolished. The Theatre Royal pantomime is one of Norwich's best Christmas traditions.

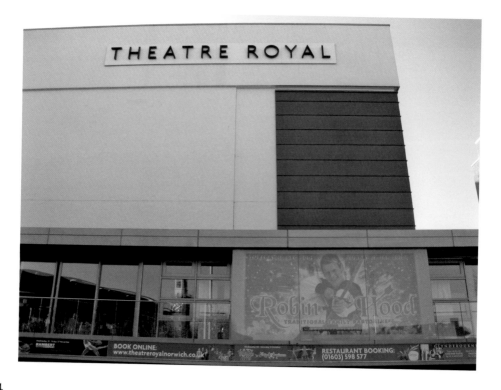

'Religious' Devotion

Saint Peter Mancroft stands right in the centre of the old Market Place, with the Provision Market on one side and the Haymarket on the other. It is a local boast that Norwich has a church for every Sunday in the year — and a pub for every day in the year! Other more secular celebrations also take place here in the heart of Norwich, as the modern photograph shows.

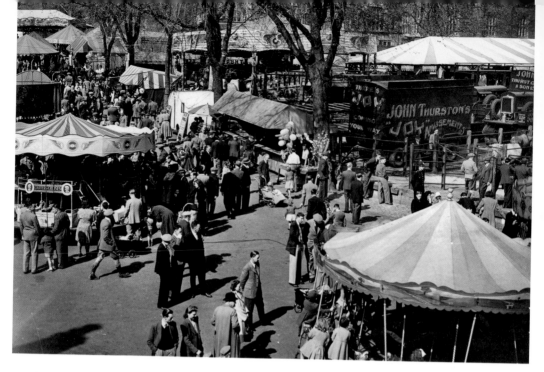

Tombland Fair

The traditional Tombland Fair has been held for centuries. In 1272, it led to riots between the people of Norwich and the monks of Norwich cathedral, during which the citizens went up the tower of Saint George Tombland church and fired flaming arrows at the cathedral setting fire to its roof. However, in more recent times the fair was held on the cattle market, but since that closed in the 1960s, the fair has not found a permanent home in the city.

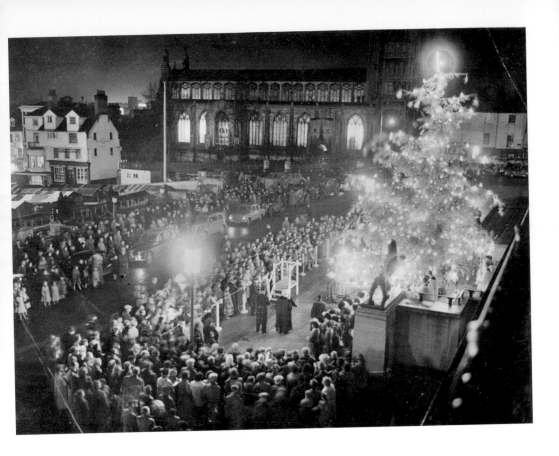

Christmas in the Heart of the City

Every year, the civic authorities place a giant Christmas tree in the city centre. In the historic picture, the lion outside City Hall looks about to jump into the heart of it, while the church of Saint Peter Mancroft, illuminated for a Christmas service, dominates the background. In 2009, the tree was in front of the Forum not City Hall; it was brought to the city from Elveden, near Thetford.

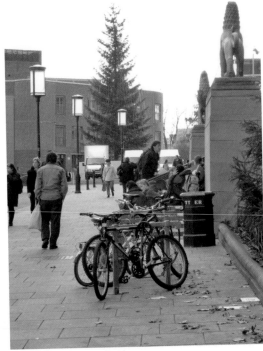

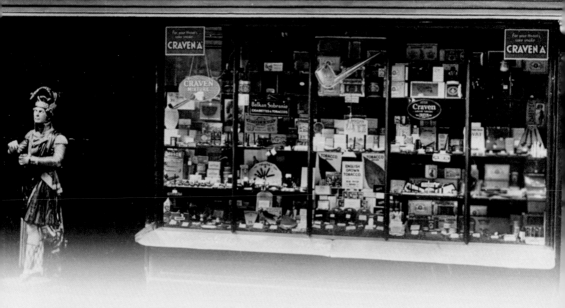

CHAPTER 8

Commercial Norwich

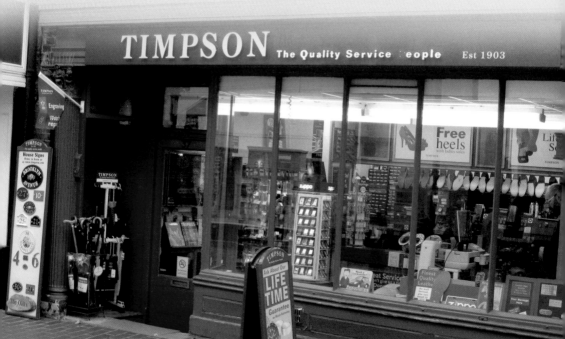

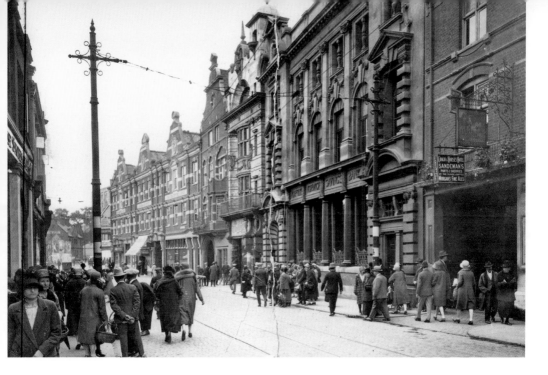

Red Lion Street

Large commercial buildings line the street, all of the period 1900-1905, after the street had been widened to allow trams to make use of it. The white building in the centre of the row is the Norfolk and Norwich Savings Bank, built in 1905 by the Norwich architect George Skipper; the building to its left, with a large Dutch gable, was built by his main Norwich rival, Edward Boardman.

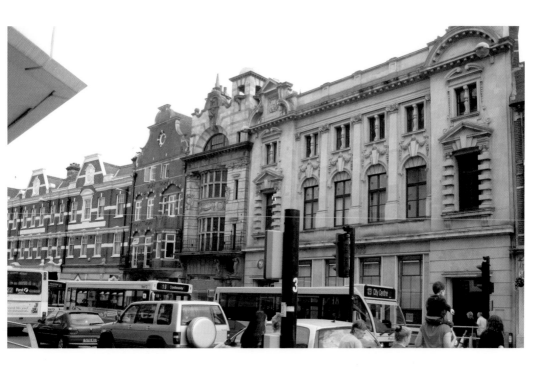

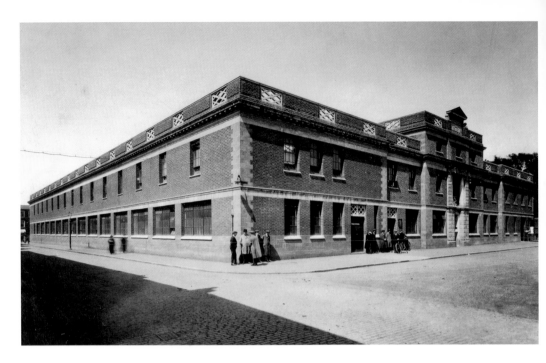

Shoe-making

Norwich had a large number of shoe factories in the nineteenth and earlier twentieth centuries. Some of the names are world-famous, such as Bally and Start-rite. This building is the Sexton, Son and Everard factory in Coslany. The large factories have now closed. Some have been demolished like Howlett and White on Silver Road, but some have been 'recycled', such as this one, which is now split into several smaller businesses, including a snooker club.

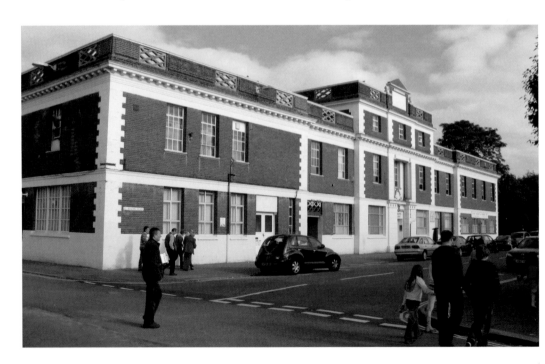

'Buntings Corner'

The junction of Rampant Horse Street, Westlegate, Red Lion Street and Saint Stephens has always been the heart of commercial Norwich. It was known as Buntings Corner after a store where Marks and Spencer now stands; a few of the older residents of the city still call it by this name. The historic photograph shows motor traffic, tramlines and evidence of horse traffic (the dark objects in the road!). The scene is very different today, but the plan is to reduce the traffic flow at this spot.

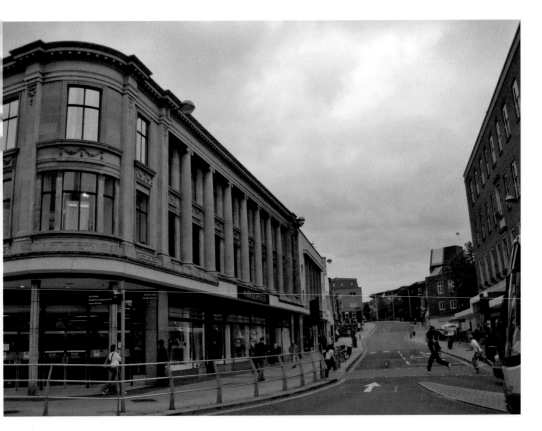

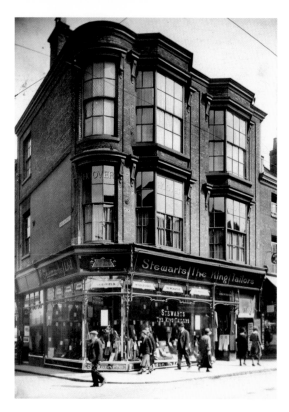

The King's Tailors
At the corner of White Lion Street and the Haymarket, Stewarts proudly boasted of being the tailor to the monarch. The property was put up for sale in 1932, and it was sold for nine thousand pounds. How much might it fetch today? The area has gained greatly from the exclusion of motor traffic.

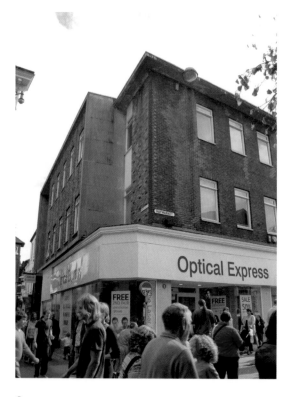

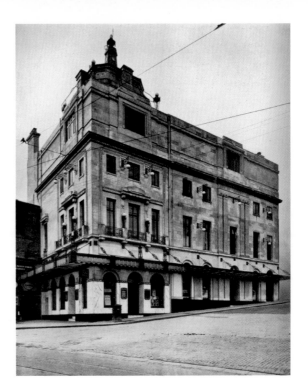

The Haymarket Cinema

Norwich had over a dozen cinemas in the 1930s to 1950s, but has far fewer now; however, with the growth of the multiplex there is probably as wide a choice of films in the city as there has ever been. The Haymarket Cinema, shown here in a photograph of 1924, was at the corner of Brigg Street and the Haymarket.

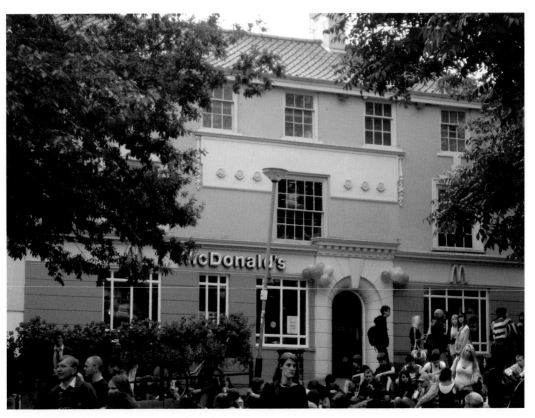

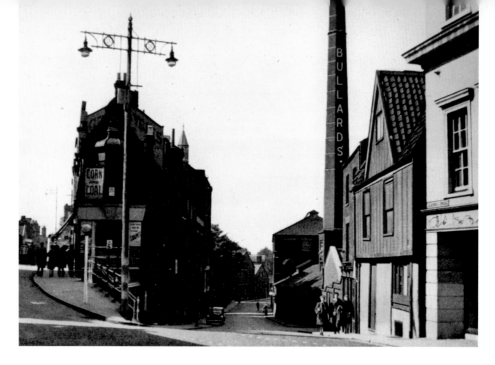

Westwick Street

The junction between Saint Benedict's Street on the left and Westwick Street on the right has always been a difficult one. The large building at the bottom of the hill and the tower are part of Bullard's Anchor Brewery, one of the four big breweries of Norwich that were swallowed up by Watney Mann in the 1960s. The brewery, which is by the river, has been converted to apartments, but the chimney could not be saved.

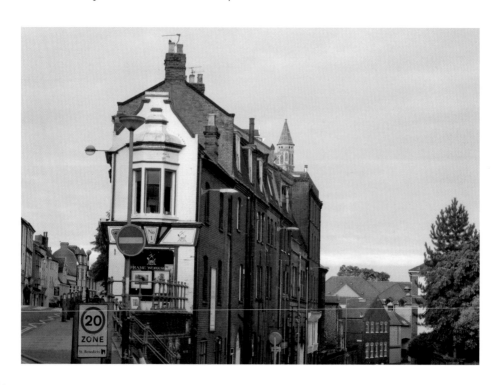

The Savings Bank
Norwich has been a centre for banking and insurance for well over two centuries, with farmers from the county bringing their savings into the city. This solid nineteenth-century savings bank building was pulled down in 1899, so that the corner could be widened for trams, which have themselves long disappeared; its early twentieth-century replacement has seen a wide range of uses.

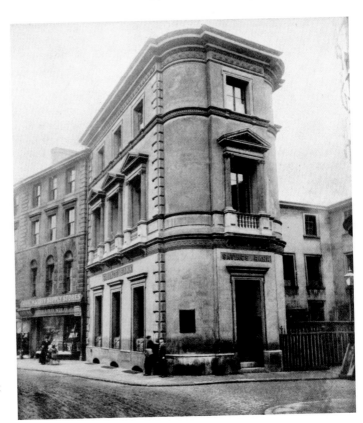

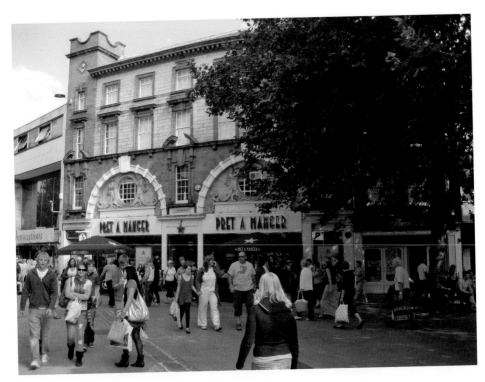

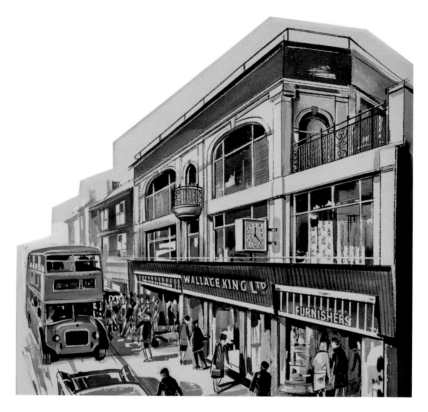

Wallace King

One of the iconic firms of the city was the furnishing store of Wallace King Ltd on the Prince of Wales Road. This building is one of the few in Norwich that can be described as art nouveau in style. Today, shops have given way to restaurants and nightclubs along the whole length of the street, which was originally built to connect the railway station to the centre of the city.

CHAPTER 9

A City Miscellany

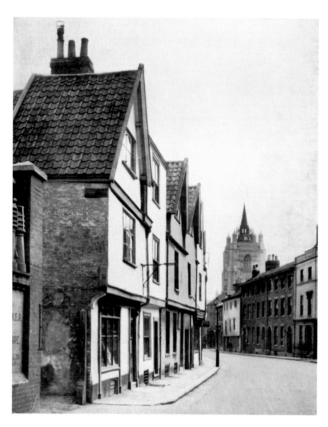

Saint Giles' Street
The fifteenth-century tower
of Saint Peter Mancroft, with
its Victorian wooden turret,
dominates the scene, which
made a nice contrast in housing
styles between sixteenth-century
buildings and grander Georgian
houses. The buildings on the
left disappeared to make way
for the fire station and City Hall
in the 1930s. Those on the right
followed after the war for the
new Central Library building.

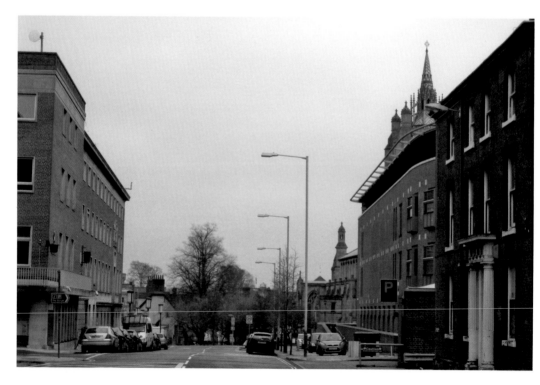

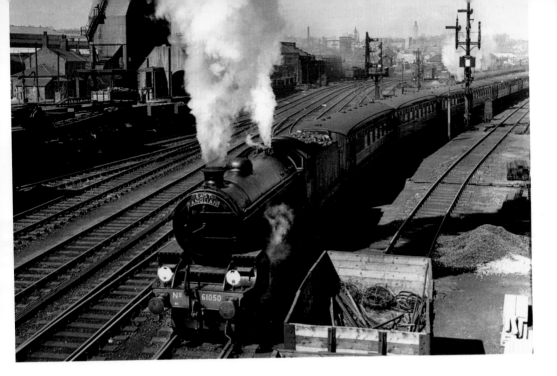

The Age of Steam

The East Anglian sets off for London in the 1950s. The train was introduced in 1937, taking 135 minutes for the journey between Norwich and London. By 1958, the time had been cut to 120 minutes. The name East Anglian disappeared in 1962. After giving way briefly to diesel, the line was electrified in 1987. Branch trains out of Norwich station use diesel multiple units.

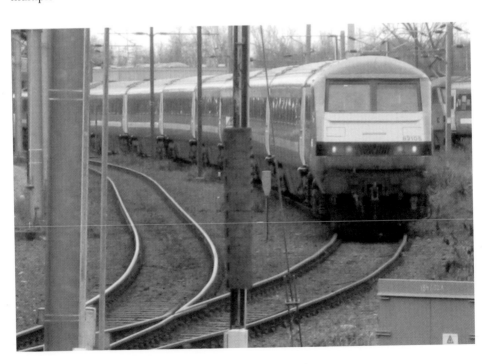

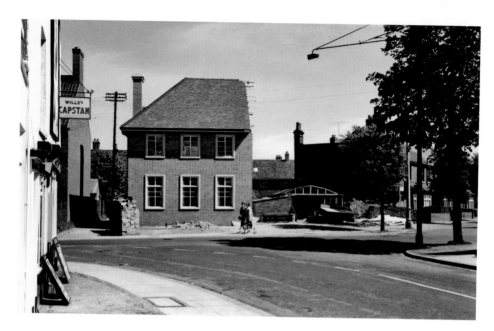

The Trafford Arms

The public house and the surrounding estate are named after the Trafford family of Wroxham, who owned the land here when it was still fields. As Norwich expanded to the west, Sigismund Trafford sold it for building purposes in the 1880s. The pub, originally owned by Steward and Patteson, another of the four great Norwich breweries, was rebuilt in about 1955 after wartime damage.

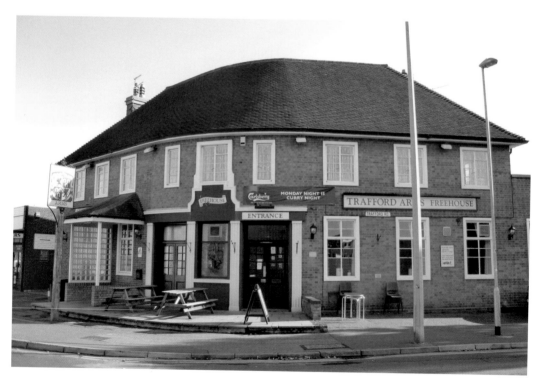

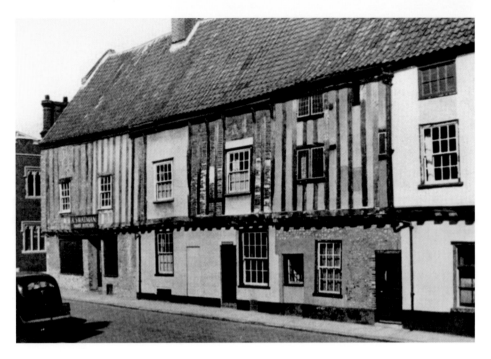

Dragon Hall

This is the grand showroom of the fifteenth-century merchant Robert Toppes, who imported and exported to Norwich via the river. Over the centuries, it degenerated into several small houses, including a public house, the Old Barge, but it has recently been restored as a very fine building and a fascinating survival of Norwich's wealth in the Middle Ages.

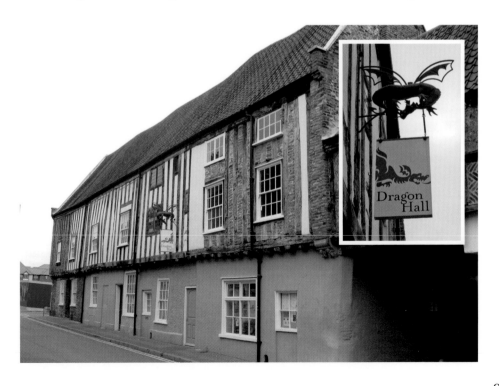

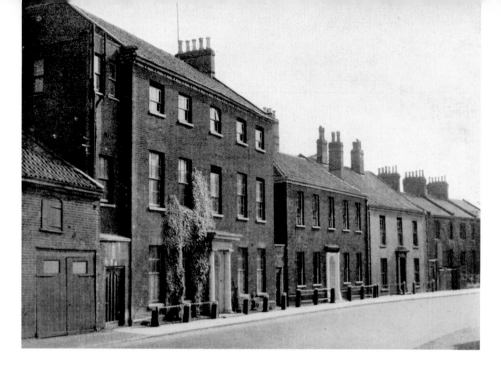

All Saints' Green

This street retains some of Norwich's best Georgian houses. William Darby, an early black resident of Norwich, was a butler in a house in this parish. His son, also William, went on to become the first black circus proprietor in Britain under the name of Pablo Fanque, and he is mentioned in a song on the Beatles' *Sergeant Pepper* album — probably the only inhabitant of Norwich to be so honoured.

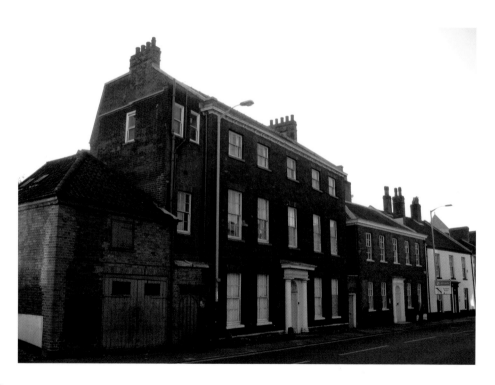

Windmills in the City

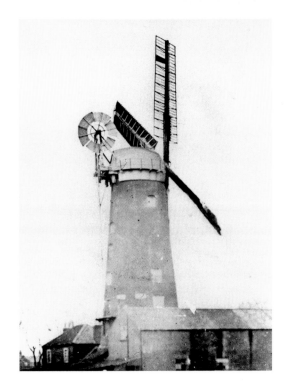

There were many windmills grinding corn in the fields around Norwich. Most of them have disappeared as the city has expanded, but some are preserved in names such as the Windmill public house on Plumstead road, shown in my *Norwich Murders and Misdemeanours*, and the street name Millers Lane near the Angel Road schools. This mill, Peafield in Lakenham, has survived and is now a private house.

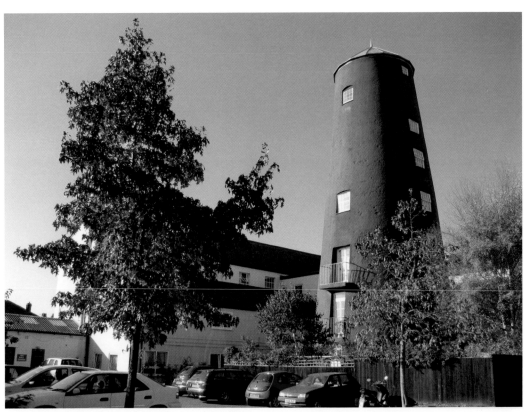

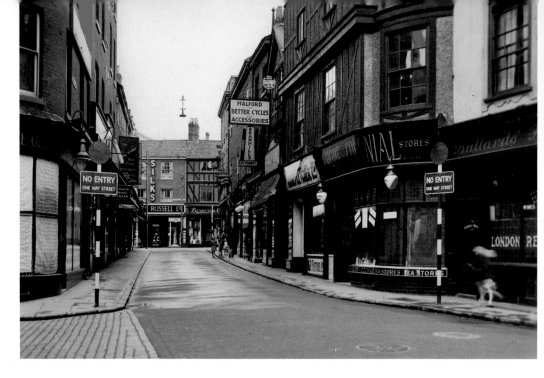

Brigg Street

Linking Rampant Horse Street with the Market Place, this is a very busy shopping street, named in honour of Alderman Augustine Briggs, who lived here in the seventeenth century and who rode the length of Norfolk raising money to have it paved. The shops on the left-hand side have disappeared under the new Debenhams, completed in 1954. However, some features of the buildings on the right-hand side are unchanged.

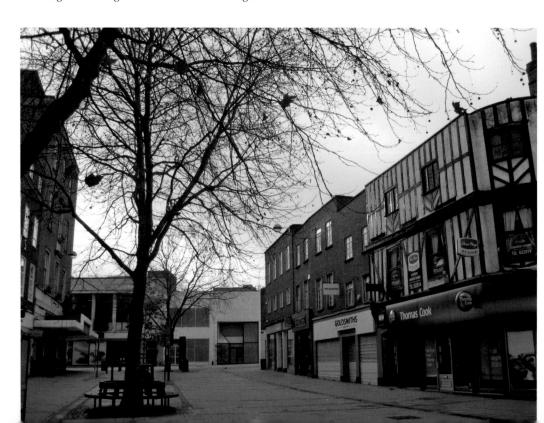

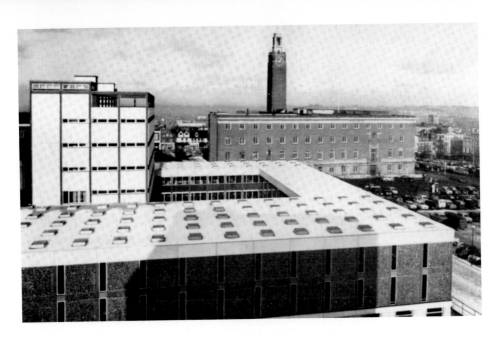

Libraries For All

Norwich opened its first public library in 1608, the earliest in Britain. This building was the first purpose-built library and archive centre in the city. Designed by city architect David Percival, it opened in 1963. It was destroyed by fire on 1 August 1994 and has been replaced by the new Millennium Library on the same site, as well as The Archive Centre beside County Hall.

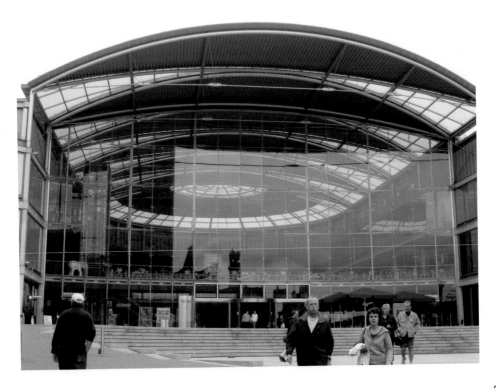

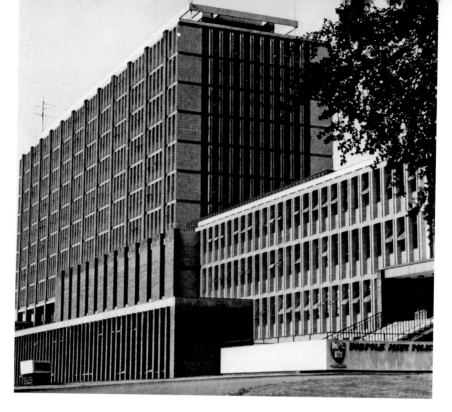

The Archive Centre

The archives of Norwich and Norfolk make up well over twelve million documents, including many of the historic photographs in this book. None of the records were destroyed in the 1994 fire, and they have now found a new home in this state-of-the-art building, which was formally opened by the Queen in 2003. Why not come along and have a look for yourself?

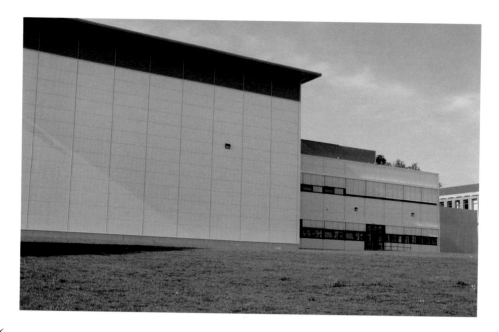